T0322506

Wild Design

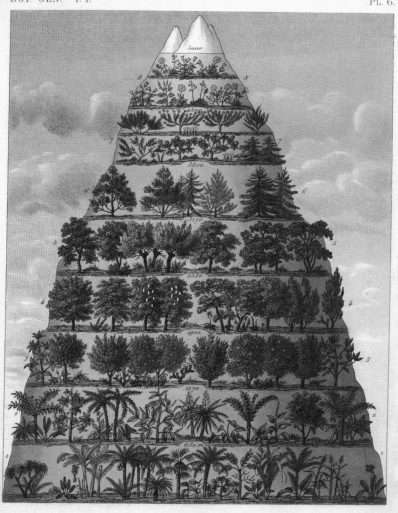

*Décroissement altitudinal de la végétation*

Maubert redux.t Lebrun sculp.t

# *Wild* DESIGN

## Nature's Architects

*Kimberly Ridley*

PRINCETON ARCHITECTURAL PRESS · NEW YORK

PUBLISHED BY
PRINCETON ARCHITECTURAL PRESS
202 WARREN STREET, HUDSON, NEW YORK 12534
WWW.PAPRESS.COM

EDITOR: STEPHANIE HOLSTEIN
DESIGNERS: PAUL WAGNER AND NATALIE SNODGRASS

LIBRARY OF CONGRESS CATALOGING-IN-PUBLICATION DATA
NAME: RIDLEY, KIMBERLY, AUTHOR.
TITLE: WILD DESIGN : NATURE'S ARCHITECTS / KIMBERLY RIDLEY.
DESCRIPTION: FIRST EDITION. | NEW YORK : PRINCETON ARCHITECTURAL PRESS,
[2022] | INCLUDES BIBLIOGRAPHICAL REFERENCES.
IDENTIFIERS: LCCN 2021005459 | ISBN 9781648960178 (HARDCOVER)
SUBJECTS: LCSH: NATURAL HISTORY—POPULAR WORKS. |
NATURAL HISTORY—PICTORIAL WORKS.
CLASSIFICATION: LCC QH45.5.R53 2022 | DDC 508—DC23
LC RECORD AVAILABLE AT HTTPS://LCCN.LOC.GOV/2021005459

# CONTENTS

# An Invitation to Wonder

What do you see when you look out the window? Perhaps you spy the twisting silhouette of an oak tree, or a spider's web shimmering with dew, or the granite facade of an apartment building next door. Maybe your window overlooks a forest or a parking lot, flower gardens or a construction site. Whatever your view, chances are it includes at least some element of nature.

As the original architect and designer, nature has been churning out stunning forms, structures, and materials for billions of years through evolution and the tremendous forces of Earth. Trees grow branches in elegant and efficient patterns. Spiders make one of the strongest materials on earth with which they spin their complex webs. Stone, even a slab of common granite, dazzles the eye with arrays of minerals fused in earth's ancient furnace. Yet we often fail to notice nature's creative genius. Staring at our phone and computer screens, we isolate ourselves from the wild world, cutting ourselves off from a powerful source of inspiration, delight, and wonder. It's a terrible loss. We become disconnected, which can lead to loneliness and despair.

This book is an invitation to reconnect and rekindle your sense of wonder. It will help you see the world beyond your window with new eyes. The pages that follow explore strange and beautiful forms made by nature, beginning with minerals and then visiting the kingdoms of protists, fungi, plants, and animals. Like a miniature cabinet of curiosities, this is but a tiny sampling of nature's astonishing designs, a quirky collection that ranges from the intricate glass houses of microscopic plankton to the ingenious nests of birds.

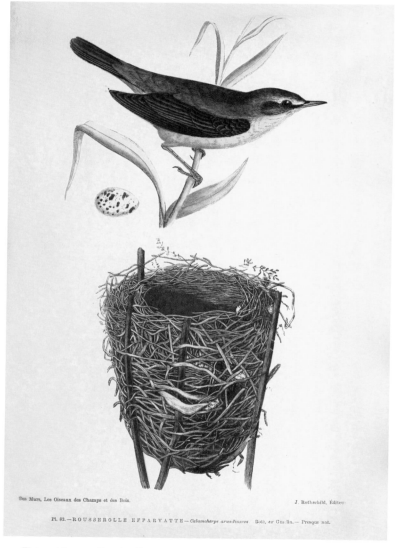

Des Murs, Les Oiseaux des Champs et des Bois.                    J. Rothschild, Éditeur

Pl. 82.—ROUSSEROLLE EFFARVATTE—*Calamoherpe arundinacea* Boié, *ex* Gmelin.— Presque nat.

The world's more than ten thousand species of birds create an astonishing range of nests, from massive communal structures that resemble haystacks in trees to shallow scrapes in the sand. The reed warbler is named for the materials it uses to weave its nest, an elegant cup of reed stems and fronds lined with a soft cushion of reed flowers.

At a time when we are bombarded with computer-generated images, the antique illustrations curated here invite the eye to linger so the mind may savor and contemplate each subject depicted — from the graceful spiral of a chambered nautilus shell to the spiky symmetry of a grain of pollen. These images deepen our collective sense of wonder with their exquisite detail, striking palettes, and artful interpretation. Created in the days before photography and vital to early science, they also offer a fascinating glimpse into visual representation during the heyday of natural history illustration in the eighteenth, nineteenth, and early twentieth centuries.

Humans have long been keen observers of the natural world. Our lives depended upon it not so long ago, and this is still true in indigenous cultures around the globe. In our hyperwired lives, however, it's easy to dismiss natural history — the close observation and study of the other-than-human world — as an antiquated and irrelevant endeavor relegated to stuffy old museums. But taking a deeper look at the wild inventiveness all around us may be key to our survival. At a minimum, it puts things in perspective and offers the possibilities of joy, connection, and wonder.

As we stare at our screens, diminutive sea creatures are building the largest "cities" on Earth. Fungi are forging underground networks that help shape the grand design of forests. Insects, birds, and other organisms are constructing extraordinary structures, perhaps in your own backyard or a nearby park. All around us, life, and the very ground itself, is building new forms, dismantling others, and recycling every atom into something else.

We humans are part of the whole shebang. After exploring the pages that follow, grab your jacket. Head outdoors. Take a look around. May you encounter wonder at every turn.

# Earth Magic

## Minerals and Rocks

Earth's crust may seem inert, a jumble of immutable stone. But many of the minerals within it have always been busy, circulating in age-old cycles that shape the foundation of the landscape—and life itself.

Forged over eons deep within the planet, Earth's four-thousand-plus minerals consist of one or more chemical elements. All minerals have an underlying crystal structure that is determined by a repeating three-dimensional pattern of atoms. For instance, salt forms in cubic crystals, quartz in hexagonal prisms, and diamonds in octahedral, or eight-sided, crystals.

Diamonds are prized for their sparkle, but we'd have little ground to stand on if it weren't for less glamorous minerals such as feldspar and quartz. Feldspar is the most common mineral in Earth's crust and also the main constituent of granite. Quartz is the second most common, and the most abundant mineral in beach sand.

Minerals fused together make up rock, of which there are three basic kinds: igneous, metamorphic, and sedimentary. Igneous rocks, such as granite and basalt, form when molten magma belched from the planet's fiery depths cools and hardens on the surface. Marble, schist, and other metamorphic rocks are the products of intense pressure and heat. Sedimentary types, such as sandstone, form when fine particles of other rocks erode and accumulate into deposits that over eons compact into stone.

Rock is always changing, albeit slowly. Wind, rain, ice, and lichens weather the stony summits of mountains, and streams and rivers erode stone, carrying fine particles downhill and depositing

them in layers that over millions of years are compressed into sedimentary rock. As this rock sinks into the earth, increasing pressure and heat transform it into metamorphic rock. If it sinks deep enough, it melts into magma—to someday spurt from a volcano and cool at the surface back into igneous rock. This process is called the rock cycle.

Powering the rock cycle is the movement of Earth's crust, which is broken into ten large plates and many smaller ones, all floating on the planet's hot, thick middle layer, the mantle. Called plate tectonics, this process transports rock between the planet's mantle and crust; creates mountains and other major geologic features; and triggers earthquakes and volcanic eruptions.

Humans have mined the planet's rocky crust for millennia in an endless quest for precious metals and gemstones, as well as for hundreds of other minerals used to make a myriad of materials, including glass and steel. Control of the earth's mineral wealth has built fortunes and empires. Yet it is perhaps some of the more humble minerals that are truly priceless, for without them life wouldn't exist. For example, calcium that leaches into the soil from limestone and other sources is absorbed by plants and used to build cell walls. When animals eat plants, their bodies metabolize that calcium to build teeth and bones. The calcium from their bones returns to the soil when they die, and the cycle continues. The material world, as well as every living thing, rises from a foundation of minerals.

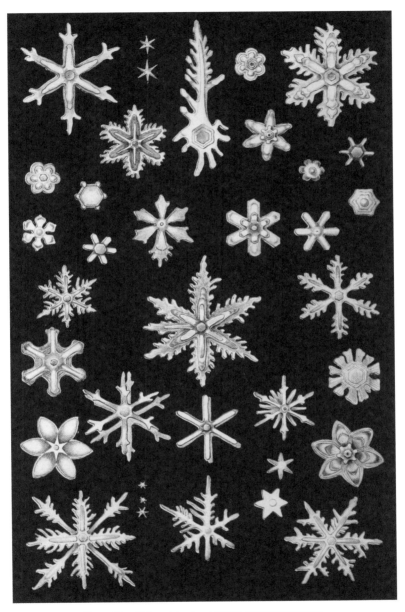

Figure 1.1 — Although ice is a mineral, liquid water is not.
Snowflakes famously form six-sided crystals, each one unique.

PLATE XVIII.

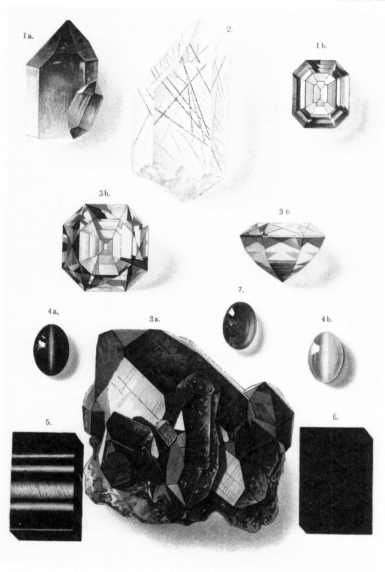

QUARTZ AND GARNET.
(1—6)          (7)

*facing page*

Figure 1.2 — Quartz is a durable mineral made of Earth's two most abundant elements: one silicon atom tightly bound to two oxygen atoms. Common on mountain summits and the major component of mineral beach sand, quartz holds up to the rough-and-tumble of weathering and erosion. Amethyst is a form of quartz that is cut into gemstones.

Hardness is a key factor in identifying minerals. In 1812, German mineralogist Friedrich Mohs developed a hardness scale using ten reference minerals, including quartz. These ten are used to scratch mineral samples to determine their relative hardness. The softest is talc, with a score of 1, and the hardest is diamond, with a score of 10. The Mohs Hardness Scale is still widely used today.

*overleaf*

Figure 1.3 — Topaz is one of only fifteen or so minerals used to make gemstones. With a hardness of 8, it is surpassed only by corundum (the mineral cut to make sapphires and rubies), and diamond.

Natural gemstones get their spectacular color variations from "impurities," trace amounts of different chemical elements. Topaz is typically colorless, yellow, or brown, but traces of chromium create the rare purples of the prized imperial topaz. Chromium also gives corundum the rich red hues of rubies, while titanium tints it with the blues of sapphires.

PLATE XIII.

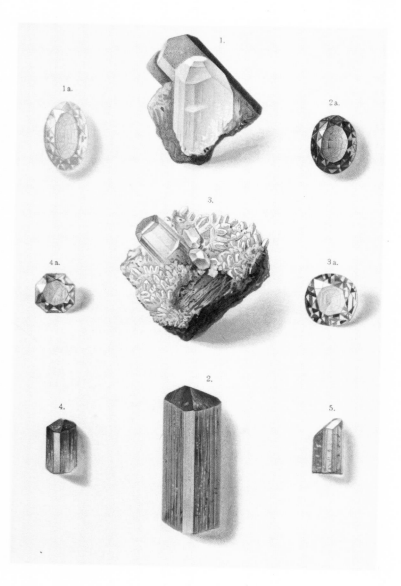

TOPAZ AND EUCLASE.
(1—4)          (5)

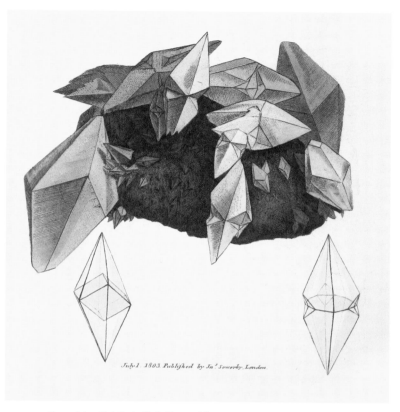

Figure 1.4 — Calcite is likely the world's most versatile mineral. It's the main constituent of limestone and marble, and it's used to make everything from cement to antacid tablets. Made of calcium carbonate, it also inspired one of the biggest discoveries in mineralogy—thanks to an accident.

One day in 1781, French mineralogist René-Just Haüy accidentally dropped and shattered a friend's prized calcite crystal. A stunned Haüy noticed that all the smaller pieces resembled the shape of the original crystal. Further experiments led Haüy to determine that the molecular structure of minerals determined their larger forms, crowning him as the founder of crystallography, the science of crystal structures and properties.

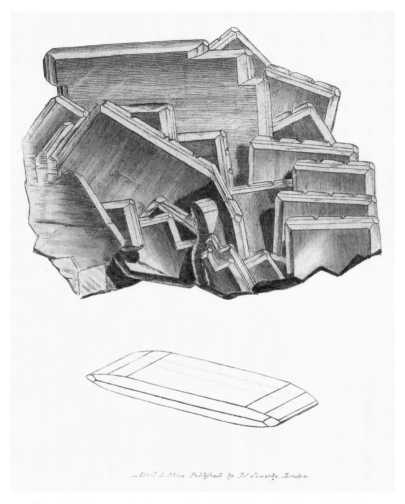

*April 2, 1804 Published by Js.º Sowerby, London*

Figure 1.5 — **The name barite comes from the Greek word for "heavy," due to its high specific gravity. With crystals that often grow in a tabular form, barite is used in industrial, medical, and manufacturing applications.**

*facing page*

Figure 1.6 — **Malachite is an example of a mineral that often takes botryoidal forms (bottom right), which resemble clusters of grapes.**

PLATE XX.

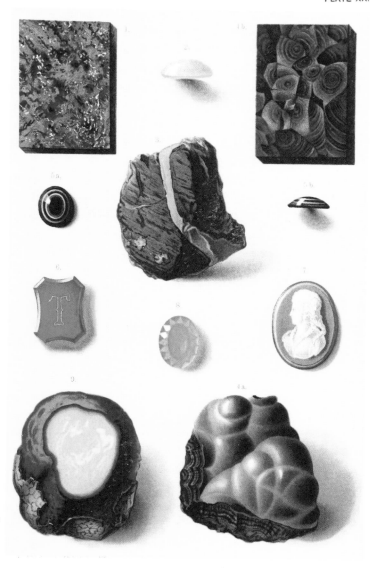

LAPIS-LAZULI, TURQUOISE, MALACHITE, CHALCEDONY AND AMBER.
(1)  (2, 3)  (4)

BOT. GÉN. T. I.                                                      Pl. I.

*upa Coupe géologique du Globe*

Figure 1.7 — **Often situated at the edges of tectonic plates, volcanoes are openings in Earth's crust that spew lava, gases, and ash. About 1,900 volcanoes are considered "active," or likely to erupt in modern day. Some volcanoes, such as Mauna Loa in Hawaii, occur in the middle of tectonic plates and are fed by magma sources deep within the lower mantle of the Earth. At 13,678 feet, Mauna Loa is the world's largest active volcano. It has erupted thirty-three times since 1843.**

*facing page*

Figure 1.8 — **Water dripping into limestone caves over centuries and millennia creates spectacular deposits of calcite and other minerals into structures called speleothems. Spiky stalactites line cave ceilings like petrified icicles, and spires of stalagmites rise from the floor. A trick for keeping them straight: think of the "t" in stalactite as standing for the "top" of the cave, and the "g" in stalagmite as standing for the ground.**

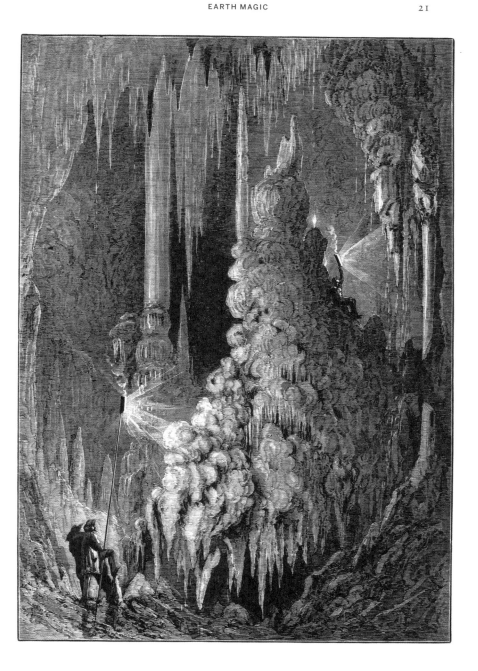

# Glass Houses

## Diatoms and Radiolarians

A drop of seawater may harbor thousands of microscopic plants and animals. These are plankton, "the wanderers," a universe of miniscule life forms that drift on the currents. They include nature's tiniest architects: diatoms and radiolarians, single-celled organisms that build intricate houses of glass.

Diatoms are microscopic algae that make transparent silica shells called frustules. Each species builds a unique shell with two halves that fit neatly together. Often patterned with pores, frustules resemble a multitude of familiar objects, including gears, sieves, pillboxes, barbells, stars, and sombreros. Safe inside these glassy homes, diatoms turn sunlight into food through photosynthesis. They pump out nearly half of the world's oxygen, stash vast amounts of carbon dioxide, and fuel marine food webs around the world.

Radiolarians build even more elaborate glass houses to protect themselves from predators. These marine zooplankton make microscopic shells of silica mesh in myriad forms, often studded with spikes. Many species are spherical. Some look like chandeliers. Others resemble rockets, snowflakes, or minarets.

No one has done more to reveal the diversity and wonder of glassmaking plankton than Ernst Haeckel, a nineteenth-century German biologist and artist. After an unhappy stint as a young physician, Haeckel spent a year abroad in Italy, where, among other adventures, he collected plankton off the coast of Sicily. Squinting into a microscope with his left eye, Haeckel kept his right eye trained on the page as he painstakingly rendered the intricate forms of hundreds of radiolarians. "Every morning I am newly amazed at

the inexhaustible richness of these tiny and delicate structures," Haeckel wrote in 1859.

Haeckel's exquisite illustrations of radiolarians star in his 1904 masterwork, *Art Forms in Nature*, which heavily influenced the art nouveau movement of the late 1880s through World War I. Architects, artists, and designers drew inspiration from the ornate forms of radiolarians and other marine life never before seen until Haeckel brought them to the page.

Scientists of Haeckel's day wondered how such simple organisms could build complex and intricate structures. It's now widely accepted that diatoms and radiolarians use their cell membranes as molds to create mesh frames of hardened silica—structures that are remarkably durable.

The glassy remains of radiolarians rest in siliceous ooze and sedimentary rock in the lightless depths of the ocean. The frustules of diatoms have accumulated over the eons and fossilized into deposits of chalk-like sedimentary rock called diatomite. Scientists and designers alike continue to study these microscopic builders, searching for inspiration and the secrets locked within the beauty of their forms.

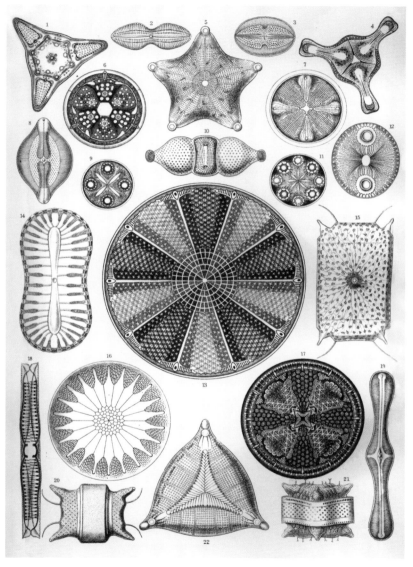

Figure 2.1 — **Diatoms and radiolarians use dissolved silica to make shells of "glass."**

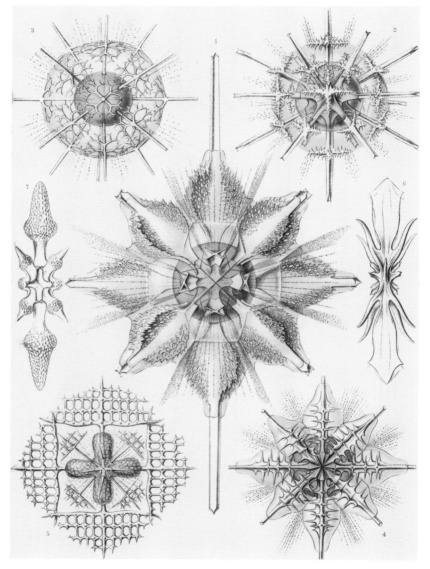

Figure 2.2 — **German biologist and artist Ernst Haeckel revealed the wonders of the microscopic architecture of diatoms and radiolarians to the world in the late nineteenth century with his meticulous and stylized drawings.**

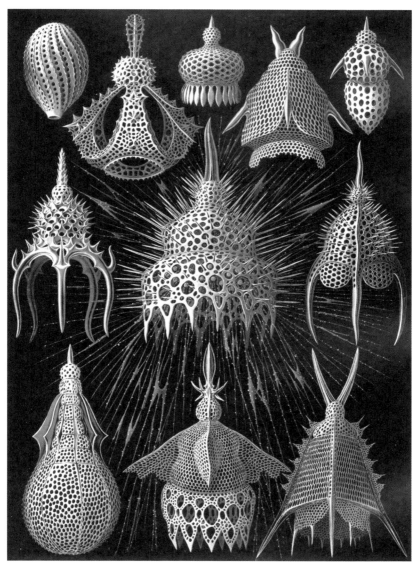

Figure 2.3 — A heartbroken Haeckel named a particularly beautiful
radiolarian *Dictyocodon annasethe* (bottom row, center) after his first wife,
Anna Sethe, who died of appendicitis on his thirtieth birthday.

Figure 2.4 — Victorian hobbyists peered through microscopes for eye-straining hours on end to make diatom art, dazzling, mandala-like assemblages, most of which could fit inside a period at the end of a sentence.

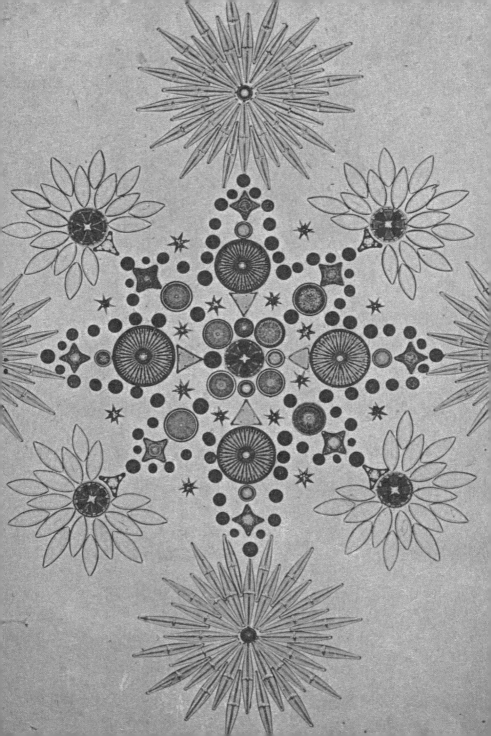

CHAPTER THREE

# Sea Sculptures

## Shells and Reefs

Sea creatures build fantastical fortresses and massive "cities" from the humblest of materials. Among the results: more than one hundred thousand different kinds of seashells, and Australia's Great Barrier Reef (which, at approximately sixteen hundred miles long, is the largest structure on the planet constructed by animals).

Mollusks are nature's most ancient animal architects. They've been making shells for five hundred million years to protect their soft bodies from predators. The two main groups of shell-building mollusks, gastropods (such as snails) and bivalves (such as scallops), create a stunning variety of forms from the same raw material—calcium carbonate, or calcite, the crumbly compound that makes up chalk.

How do shells made of such a brittle material survive the crashing of the waves and the intense pressure of the depths? It turns out that mollusks add tiny amounts of proteins to calcite to build their shells. Through an organ called the mantle, they first secrete a frame of proteins and then cover it with calcium carbonate. The microscopic proteins act as steel rods over which the calcium carbonate hardens like cement.

Many mollusk shells, such as abalone and mussels, also have an inner reinforcing layer of iridescent mother-of-pearl, or nacre. Although nacre is also made from calcite, it has an entirely different microscopic structure: flat, hexagonal crystals of calcite are layered with proteins like bricks and mortar. This structure makes nacre remarkably resistant to cracking. The crystals also diffract light, which gives nacre its iridescence and pearls their luster.

As mollusks grow, they enlarge their shells on the outer edge. One of the most beautiful examples is the chambered nautilus, a cephalopod whose coiled shell is prized for its elegant spiraling compartments. Nautilus and snail shells grow in a mathematical spiral that follows the Fibonacci sequence, a numerical pattern named for the Italian mathematician who introduced it in the early thirteenth century. This logarithmic spiral is found throughout nature in scales as small as the center of a sunflower (see pages 66–67), and as vast as a galaxy.

Like mollusks, corals also build shelters of calcium carbonate. Individual coral polyps, tiny relatives of sea anemones, secrete calcium carbonate, which hardens into minute cups that protect their flimsy bodies. Over millennia, colonies of the stony corals build massive reefs that are among the most diverse ecosystems in the world. It is estimated that 25 percent of all sea creatures depend on coral reefs, which are often called "cities of the sea."

Humans have treasured shells and corals for centuries, using them for currency, adornment, tools, and tableware. Seashells have also inspired architects and designers for centuries, from the spirals adorning the Ionic columns of ancient Greece to the shell motifs and swirling embellishments of the rococo movement of eighteenth-century France.

Elegant, durable, and mysterious, seashells endlessly fascinate. No wonder one can't resist collecting these marvelous creations, built by some of the most ancient architects on Earth.

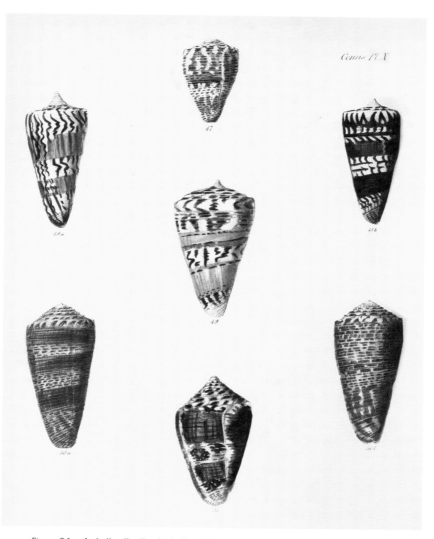

Figure 3.1 — A shell collection including a "glory of the sea cone" (*Conus gloriamaris*) fetched nearly as much as a Vermeer painting at an Amsterdam auction in the eighteenth century during the height of "conchylomania," an obsession with exotic seashells. Wealthy Europeans displayed the shells—brought back on ships from the Dutch East India Company and other vessels—in their cabinets of curiosities, rooms packed with natural treasures and art.

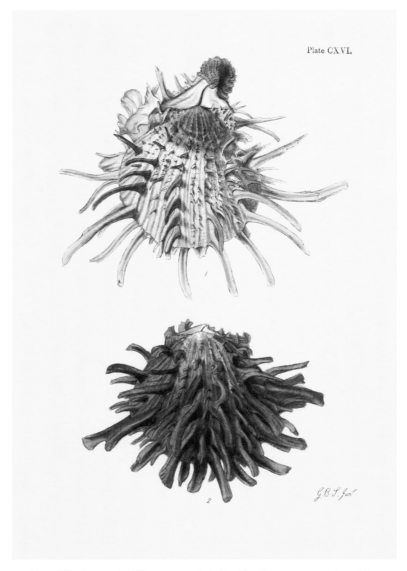

Plate CXVI.

Figure 3.2 — Incas valued the orange-red shells of the thorny oyster, or *Spondylus*, more than gold, according to an account in 1525 by Spanish conquistador Francisco Pizarro, who traded the shells for gold, silver, and other treasures. They cast the shells into wells and springs as offerings to ensure a reliable supply of water and also worked the shells into beads and exquisite ornaments.

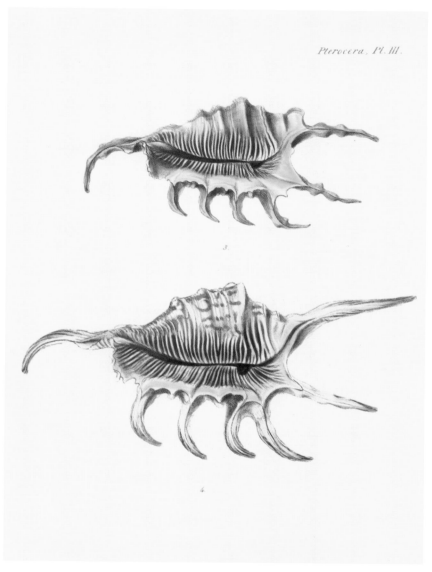

*Pterocera, Pl. III.*

Figure 3.3 — **The scorpion conch, *Lambis scorpius*, is an example of the many mollusks that have evolved spiky shells to protect themselves from predators.**

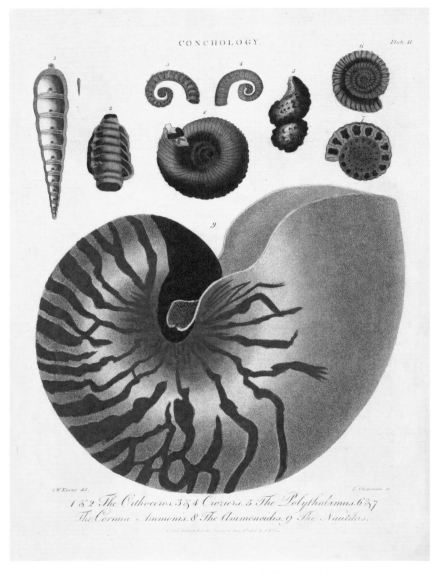

Figure 3.4 — **The chambered nautilus uses its shell as a sort of submarine.**
A nautilus regulates the proportion of gases and seawater in the spiraling chambers
inside its shell to sink or float. These ancient mollusks are now endangered
due to overharvesting for their spectacular shells.

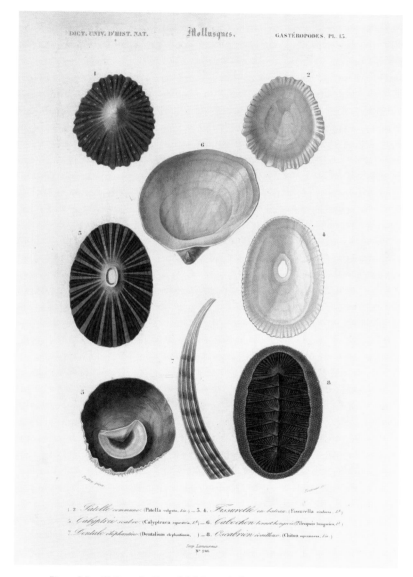

DICT. UNIV. D'HIST. NAT.   Mollusques.   GASTÉROPODES. PL. 15.

Figure 3.5 — Chitons (bottom right) have shells consisting of eight plates.
Many of the nearly 950 species of this often brilliantly colored mollusk can be found in
tide pools. Chiton shells are commonly known as coat-of-mail shells or cradle shells.
When threatened, chitons can curl up into tiny balls, like pill bugs.

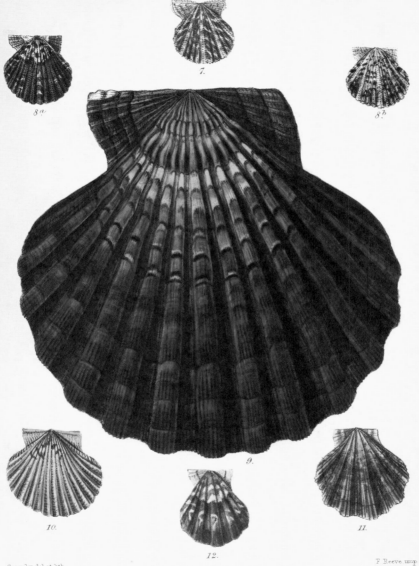

Sowerby, del et lith.

F Reeve imp

*facing page*

Figure 3.6 — The giant seashell in Botticelli's *The Birth of Venus* (circa 1485) is most likely the Mediterranean scallop (*Pecten jacobaeus*), or the great scallop (*Pecten maximus*). Even if it is the latter, Botticelli exaggerated its size—the largest great scallop is just over six inches across.

*overleaf - p.40*

Figure 3.7 — Colonies of coral polyps have been building limestone reefs in the world's tropical oceans for more than four hundred million years. Stony coral polyps have a symbiotic relationship with singled-celled algae that give corals their rainbow colors and help build their calcite skeletons. When the polyps die, these skeletons remain, and new generations build on top of them. Over eons, hard corals form enormous reefs like living mountains under the sea.

*overleaf - p.41*

Figure 3.8 — Stony corals make diverse and intricate forms, from antler-like structures to crinkly brain coral in mounds the size of boulders.

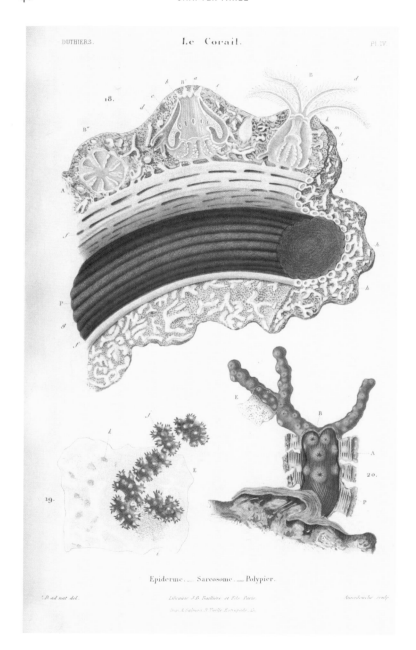

DUTHIERS. Le Corail. PL. IV.

Epiderme. — Sarcosome. — Polypier.

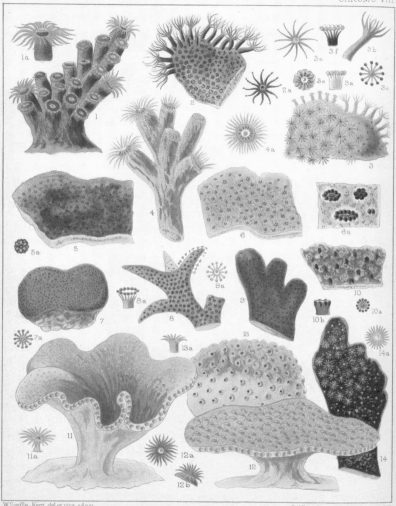

CHROMO VIII.

W. Saville-Kent, del et pinx. ad nat.

Riddle & Couchman, Imp. London, S.E.

GREAT BARRIER REEF CORALS.

# *Fabulous Fungi*

## Demolition Crews and Network Builders

Mushrooms dotting the forest floor are like the tips of tiny icebergs: they merely hint at the larger mystery hidden below the surface. The fruiting bodies of fungi, mushrooms appear only when conditions are right for releasing their spores. But the vast networks of fungal filaments that produce them are ever-present and uncountable underground, where they help shape the grand design of forests.

Turn over a shovelful of forest soil and you may see delicate, rootlike threads webbing the earth and leaf litter. This is mycelium, the main body of a fungus, which is made up of dense tangles of branching microscopic filaments called hyphae. Fungi play two major roles in the forest through their mysterious mycelia: demolition and building networks.

Most fungi are members of "demolition crews." These decomposers, which include oyster mushrooms, feed on dead plants and animals. Forests depend on their unique talents: fungi are the only organisms that can break down lignin, and they are the main decomposers of cellulose, both of which give the woody tissue in trees and other plants strength and rigidity. If not for these saprotrophic, or "death-eating," fungi, forests would be buried under their own dead weight, and trees would struggle for sustenance.

Thousands of other fungi forge networks in symbiotic relationships with plants. These mycorrhizal fungi, for example, such as truffles and chanterelles, colonize tree roots and help plants absorb mineral nutrients and water in exchange for sugars from photosynthesis. And it doesn't stop there. Mycorrhizal fungi connect many trees in a forest in vast and complex networks scientists have

nicknamed "the wood wide web." Trees use these networks to share nutrients with neighbors and offspring—and even to warn one another of danger. When insects attack, trees under siege can send chemical signals through fungal networks to warn their neighbors to start producing toxic compounds.

Not all fungi, however, are beneficial. Some are parasitic and cause disease, including the largest organism in the world—a honey mushroom, or *Armillaria ostoyae*—found in Oregon. Its mycelium spans more than three square miles, as measured by a patch of dead and dying trees.

Long lumped together with plants, fungi belong to a kingdom all their own, with more than 200,000 species described, and an estimated five million thought to exist. In addition to mushrooms, this kingdom includes sac fungi, mold, single-celled yeast, and lichens, a symbiotic relationship between fungi and algae. Surprisingly, fungi are more like animals than plants in at least two ways: they can't make their own food and they produce enzymes to digest their "meals."

Terrestrial life wouldn't exist if not for these bizarre and ancient beings. More than four hundred million years ago, fungi formed a symbiotic relationship with liverworts that enabled these tiny, primitive plants to spread from the edges of prehistoric ponds to dry land and eventually evolve into the plant life we know today, including forests. The next time you spot mushrooms in the woods, at a park, or in your own backyard, imagine the history, the transformations, and the silent conversations happening right under your feet.

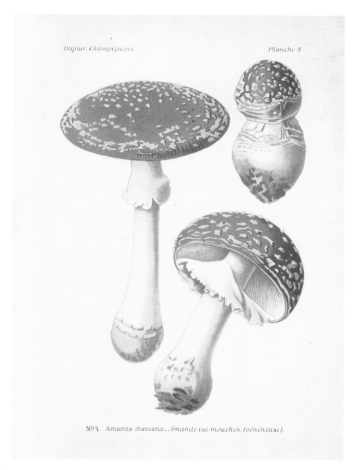

Dujour, Champignons

Planche 3

N°4. Amanita muscaria..Amanite tue-mouches. (vénéneuse).

Figure 4.1 — Straight from the pages of a fairy tale, *Amanita muscaria*, or fly agaric, is one of about ten thousand gilled mushrooms. Densely packed gills, or lamellae, on the undersides of the caps produce and release microscopic spores. One gilled mushroom can release billions of spores.

Some scholars playfully posit that *Amanita muscaria* may have helped inspire the modern Santa Claus. Sami shamans in Lapland once used these toxic, hallucinogenic mushrooms for healing ceremonies during the winter solstice. They dressed in red and white, traveled in sleds drawn by reindeer, and entered homes with their sacks of mushrooms through smoke holes in the roof when snow blocked the doors. Families fed the shamans in gratitude for the gifts of healing. It's unclear how much of this is literally true, but eating this species of *Amanita* can cause the sensation of flying. And reindeer like them too.

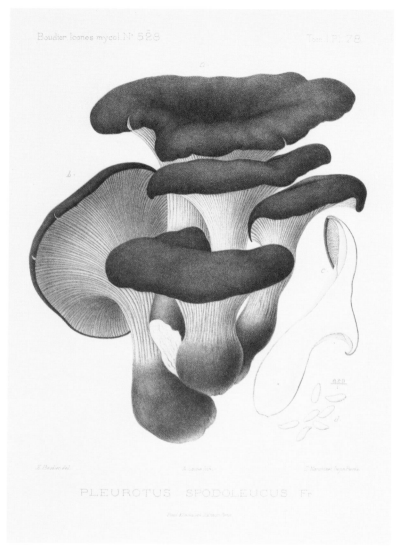

Figure 4.2 — Oyster mushrooms, which belong to the genus *Pleurotus*,
demonstrate the power of fungi to clean up pollution. Scientists have discovered
that certain strains of oyster mushrooms can break down the hydrocarbons
in fuel oil spills on the ground. In some cases, oyster mushroom mycelia digested
the oil so completely that no traces of pollutants were found in their flesh.

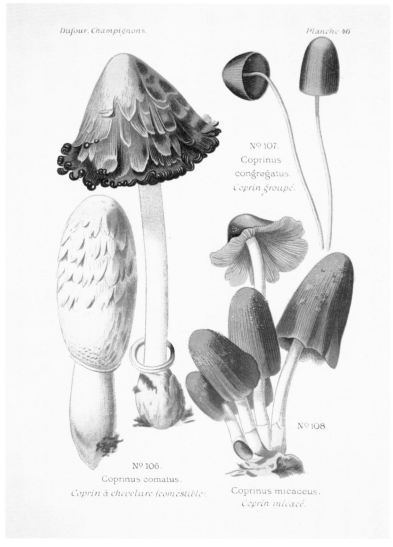

*Dufour, Champignons.*

*Planche 46*

Nº 107.
Coprinus
congregatus.
*Coprin groupé.*

Nº 108.

Nº 106.
Coprinus comatus.
*Coprin à chevelure (comestible)*

Coprinus micaceus.
*Coprin micacé.*

Figure 4.3 — Edible *Coprinus comatus* mushrooms are commonly called
"shaggy manes." Collectively known as "inky caps," *Coprinus* mushrooms
employ a fascinating strategy to disperse their spores. Starting at the bottom,
they gradually digest their own caps, releasing spores in the process and
causing the caps to turn black. And yes, their spore-blackened caps
were once used to make ink.

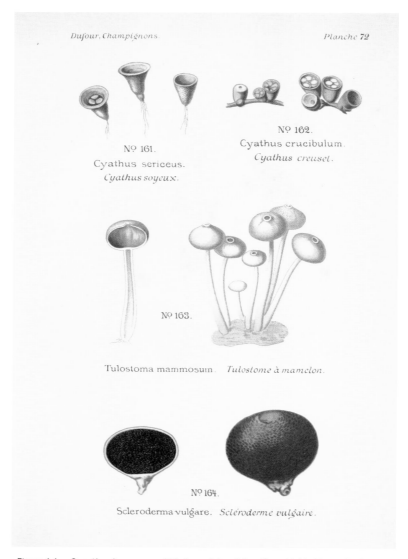

Figure 4.4 — *Cyanthus* is a genus of bird's nest fungi. Small as shirt buttons, the fruiting bodies consist of round "nests," holding egg-like structures filled with spores. Raindrops splashing into the nests, or peridia, launch the eggs, or peridioles, into the air, where they stick to twigs and the spores eventually germinate.

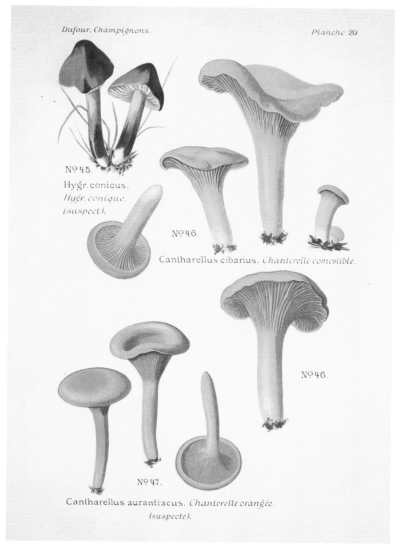

*Dufour, Champignons.*  *Planche 20*

Nº 45.
Hygr. conicus.
*Hygr. conique.*
*(suspect).*

Nº 46.

Cantharellus cibarius. *Chanterelle comestible.*

Nº 46.

Nº 47.

Cantharellus aurantiacus. *Chanterelle orangée.*
*(suspecte).*

Figure 4.5 — Smelling of apricots, orange-gold chanterelles (*Cantharellus cibarius*) are among the world's most coveted edible mushrooms. These mycorrhizal fungi forge symbiotic relationships with conifers such as spruce and fir, as well as oak and beech trees. Because this relationship is so complex, chanterelles cannot be cultivated.

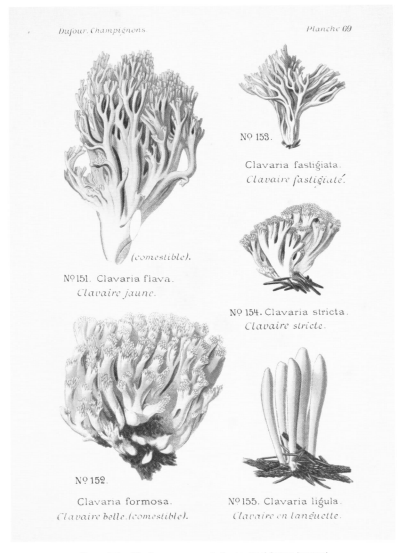

Figure 4.6 — **Mushrooms come in fantastical forms beyond the classic stalk and cap.** *Clavaria* **mushrooms are prime examples, and were originally named for their resemblance to coral.**

Tab 325

St Vincent Fungi.

G Massee del.
R Morgan lith.

West, Newman imp.

Figure 4.7 — *Dictyophora* mushrooms (center) are among the aptly named stinkhorns.
There's no polite way to describe them. They produce slimy, reeking masses of spores that
attract carrion-loving flies, who eventually spread the spores to rotting carcasses
where they can germinate. Then there's the shape: stinkhorns belong to the order Phallales,
derived from the word phallus. Perhaps that's why certain *Dictyophoras*, all of
which have intricate veils, are cultivated, cooked, and served as aphrodisiacs in China.

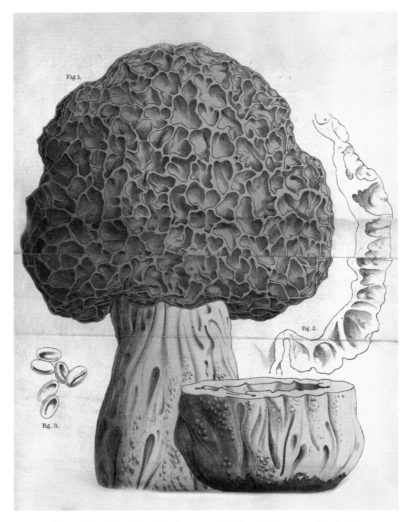

Figure 4.8 — **Prized by chefs, true morels belong to the genus** *Morchella*,
an old German word for mushroom. These elusive mushrooms are sac fungi and
include truffles, cup fungi, lichens, and most yeasts. Belonging to Ascomycota,
the largest phylum of fungi, they produce spores inside sac-like cells called asci.
In members of the Basidiomycota phylum, such as oyster mushrooms,
spores develop on projections studding the outside of cells called basidia.

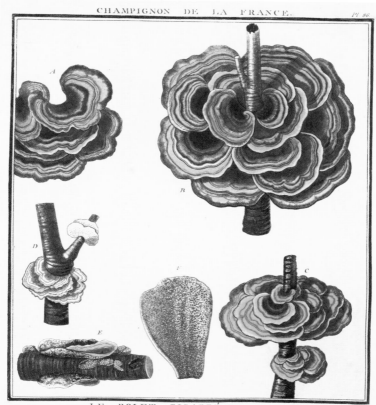

Figure 4.9 — Turkey tails, or *Trametes*, are one of the few mushrooms that might be seen any time of year on a walk in the woods. These bracket fungi grow on dead trees and rotting logs, sometimes in large, showy clumps, especially when they're fresh. Banded in gray, brown, rust, and sometimes blue, a turkey tail's beautiful pileus, or upper surface, protects a pale underside riddled with spore-producing pores.

# Brilliant Botany

## The Design Genius of Plants

Plants are the design wizards of the living world. Over the past five hundred million years, they have evolved from primordial pond scum into a dazzling array of forms, from duckweed, the world's smallest flowering plant, to redwoods, the world's tallest trees. Each conjures food from thin air, using sunlight to turn carbon dioxide and water into sugars through the magic of photosynthesis.

The variations in the world's approximately four hundred thousand species of plants boggle the mind, but botanists have divided them into four broad groups: mosses and liverworts, ferns, conifers, and flowering plants. Plants are further classified by their architectural structure, including branching patterns and the size, position, and shape of leaves and flowers.

Leonardo da Vinci sketched the branching patterns of trees, jotting down a fascinating observation in a notebook five hundred years ago: "All the branches of a tree at every stage of its height when put together are equal in thickness to the trunk below them." In other words, when a tree trunk forks into branches, the sum of their cross sections equals the thickness of the trunk, and this relationship continues each time a branch divides, right up to the smallest twigs. This phenomenon came to be called da Vinci's "rule of trees."

Trees branch out as they grow for many reasons. Branching ensures that leaves receive optimal exposure to sunlight, which they capture with chlorophyll in order to complete photosynthesis. This pattern also protects limbs from snapping by reducing wind resistance, and branching helps trees efficiently transport water from roots to leaves.

Each species of tree has a unique branching pattern and form, but environmental factors such as light, soil, water, and wind affect an individual tree's particular shape. The same is true of all plants, which also have a sense of touch—and grow in response to wind and other mechanical stimuli. This process is called thigmomorphogenesis, from the Greek *thigmo* for "touch," *morpho* for "form," and genesis for "*origin*," in other words, a form originating from touch. One dramatic example is a gnarled and stunted tree growing on an exposed mountaintop buffeted by wind. Unable to pack up and move, trees and other plants are constantly making decisions as they respond to conditions around them—aiming to strike a balance between remaining stable in heavy weather, gathering sunlight, and living alongside their arboreal neighbors.

Leaves come in two basic arrangements, simple and compound, and in about twenty shapes—from the linear needles of a spruce tree to the handlike, or palmate, leaves of a maple to the round, or orbicular, leaf of a lotus. Compound leaves are divided into smaller leaflets and grow either in a fanlike pattern or along a stalk. They are less likely than large, simple leaves to tear off in high winds. Palm trees have compound leaves, which, in addition to flexible trunks and extensive networks of roots, help them survive in places prone to hurricanes.

Other leaves are outliers. For example, the specialized leaves of carnivorous plants, such as the pitcher plant, trap and "digest" insects to obtain nitrogen and other nutrients not available in the poor-quality, waterlogged soils in which they grow. Cactus spines also evolved from leaves.

The basic blueprint of a flower, a plant's reproductive structure includes petals surrounding a ring of slender stamens tipped with pollen-dusted anthers that encircle the pistil. These elements have given rise to a riotous array of flower forms and colors (not to mention fragrances) since the first flowers bloomed on Earth about 140 million years ago. Flowers may grow singly or in clusters, and

come in about a dozen forms, such as the trumpet-shaped blossoms of petunias and the urn-like flowers of blueberries.

Following pollination, flowers produce seeds, elegant packets of life. Each seed contains an embryonic plant sheathed in a protective case. Seeds come in a wide variety of sizes and forms. The smallest are the dust-like seeds of orchids, and the largest are those of the Coco-de-Mer palm of the Seychelles Islands, which can weigh up to forty-five pounds.

Stunning and functional in equal measure, plants have inspired architects and designers since ancient times. For example, the Egyptians built sandstone columns modeled after bundles of budded papyrus stalks to support the massive stone roof of the Luxor Temple, which dates back to 1400 BC. The Greeks and Romans constructed treelike columns and carved elaborate capitals embellished with acanthus leaves and other plants. More than two thousand years ago, the Chinese used wooden dugong brackets, cantilevered structures inspired by tree branches, to support the roofs of temples and palaces, some of which stand despite centuries of earthquakes. Perhaps the most well-known examples of such dendriforms, or treelike structures, are the vaulted ceilings of medieval churches.

It's no wonder that plants have continued to inspire architects in recent times as well, from the plantlike cast-iron forms of the art nouveau movement to the sustainable building practices of present day. In addition to their beauty, plants have mastered the art of staying put, gracefully adapting to every rigor life presents—all while providing shelter and food to countless species and creating the very air we breathe.

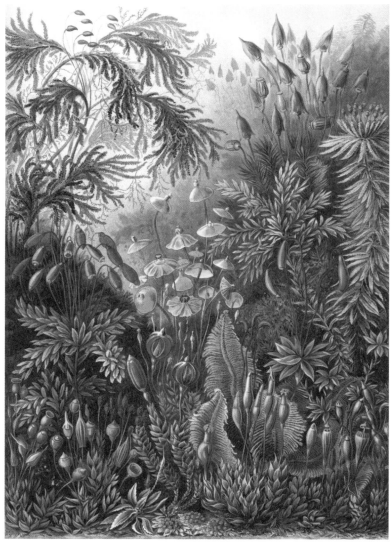

Figure 5.1 — **Mosses are some of the Earth's most ancient plants—and among the first to green a barren planet about 350 million years ago. Lacking roots, mosses absorb water and nutrients through their surfaces and can grow on bare rock.**

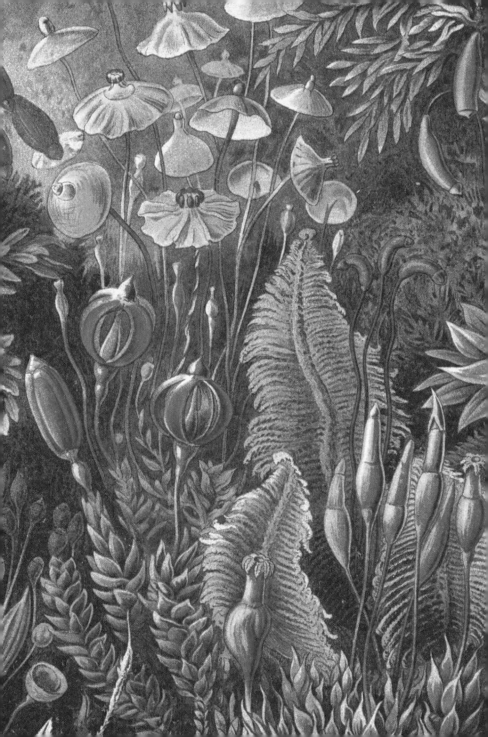

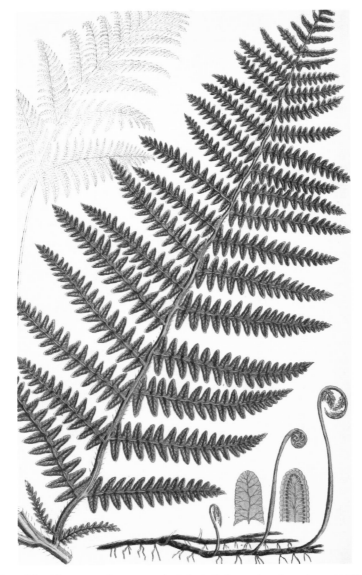

Figure 5.2 — **Like mosses, ferns are ancient plants that reproduce through spores rather than seeds. After unfurling from tightly coiled fiddleheads, fern fronds typically grow in fractal patterns. One of the most ancient is the royal fern, which has survived largely unchanged since the Jurassic period and weathered the cataclysms that wiped out dinosaurs and most other life on land.**

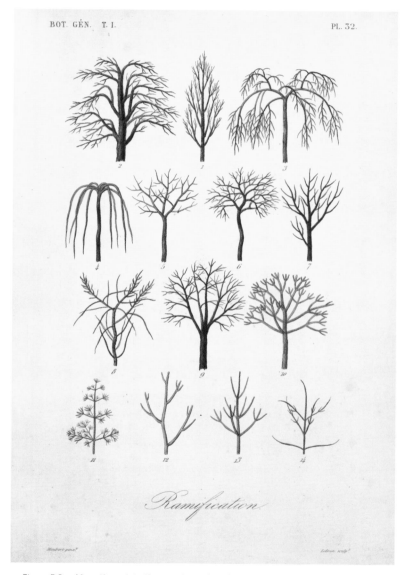

*Ramification*

Figure 5.3 — More than sixty thousand species of trees have been found in the world, with new species being discovered every year. Trees grow in nine basic shapes, such as open, columnar, and weeping (top row). Other tree forms include conical, pyramidal, vase-shaped, round/oval, spreading, and irregular.

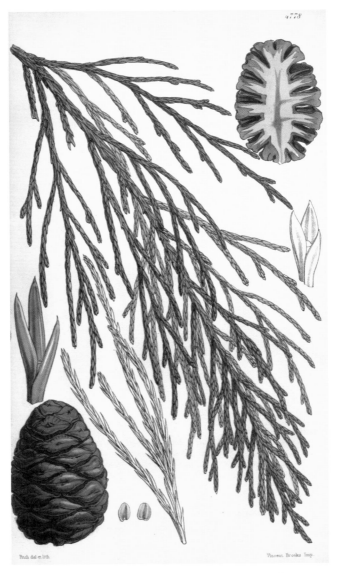

Figure 5.4 — **Conifers, such as sequoias, redwoods, spruce, fir, pine, and cedar, produce cones rather than flowers. Unlike flowering plants, these cones contain "naked" seeds that are not embedded in fruit.**

Figure 5.5 — Leaves come in about twenty shapes, including
(clockwise from top left): palmate (handlike), cordate (heart-shaped),
lanceolate (lance-shaped), and pinnate (feather-shaped).

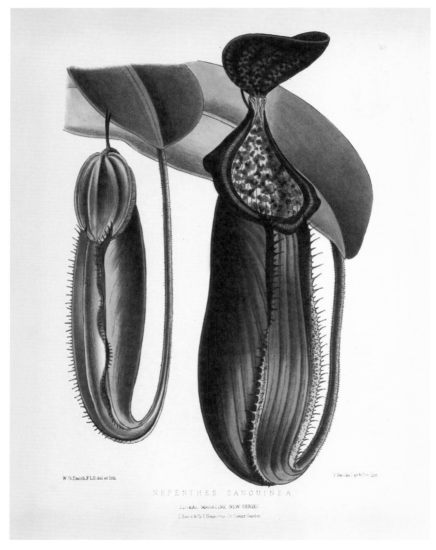

NEPENTHES SANGUINEA.

Figure 5.6 — The "pitchers" of carnivorous pitcher plants are actually modified leaves that work as pitfall traps to catch insects. Nectar lures insects inside, and slick inner walls prevent them from escaping. Eventually, they drop into a pool of water at the bottom, where they slowly dissolve into plant food. This is just one ingenious strategy employed by carnivorous plants. For example, sundews trap insects with sticky leaves, while Venus flytraps use the classic "snap trap" approach triggered by exquisitely sensitive hairs on each leaf.

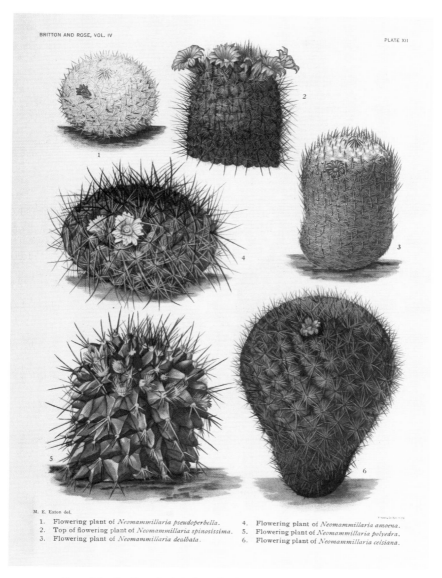

1. Flowering plant of *Neomammillaria pseudoperbella*.
2. Top of flowering plant of *Neomammillaria spinosissima*.
3. Flowering plant of *Neomammillaria dealbata*.
4. Flowering plant of *Neomammillaria amoena*.
5. Flowering plant of *Neomammillaria polyedra*.
6. Flowering plant of *Neomammillaria celsiana*.

Figure 5.7 — Cacti conduct photosynthesis primarily in their stems rather than their leaves, which have evolved into spines that protect these water-storing desert dwellers from hungry and thirsty creatures.

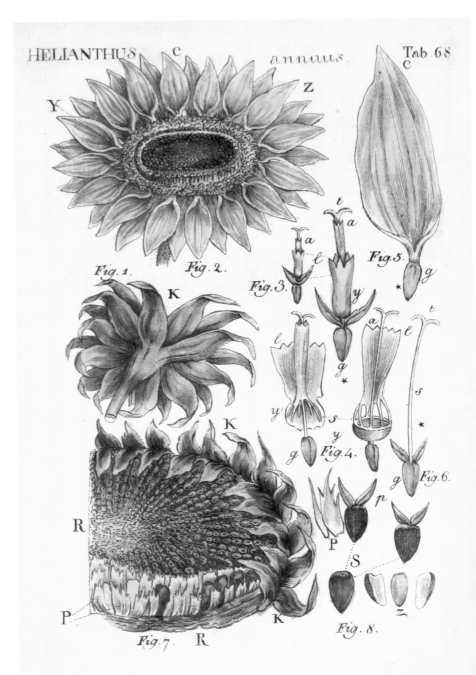

HELIANTHUS    C    annuus.    Tab. 68

Fig. 1.    Fig. 2.

Fig. 3.    Fig. 5.

Fig. 4.

Fig. 6.

Fig. 7.    Fig. 8.

*facing page*

Figure 5.8 — The blossoms of sunflowers and many other members of the daisy family are more complex than they appear. What looks like a single flower is actually composed of hundreds, sometimes thousands, of tiny flowers called florets. Tubular florets make up the central disks of these flowers. Like the nautilus shell, these florets grow in a logarithmic spiral following the Fibonacci sequence. Each "petal" surrounding the disk is also a floret. Packing in so many florets is a successful way to attract pollinators: with nearly twenty-five thousand members, the daisy family, or Asteraceae, is one of the largest families of flowering plants.

*overleaf*

Figure 5.9 — More than 250,000 species of flowering plants bloom around the planet. To name and organize the astonishing diversity of plant and animal life, Swedish botanist Carl Linnaeus created a system of taxonomy in the mid-1700s. He sorted organisms into five categories of increasing specificity: kingdom, class, order, genus, and species. Linnaeus scandalized some fellow scientists by categorizing plants according to the sexual parts of the flowers, the stamens (male organs) and pistils (female organs). His approach to classifying plants was deeply flawed and later replaced, but much of the structure of his larger system remains in use today—with constant updates as we learn more about life on Earth.

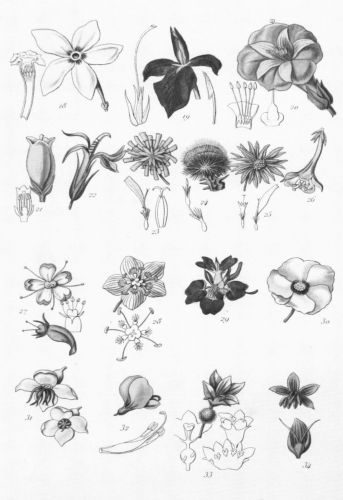

*Méthode naturelle de L. de Jussieu*

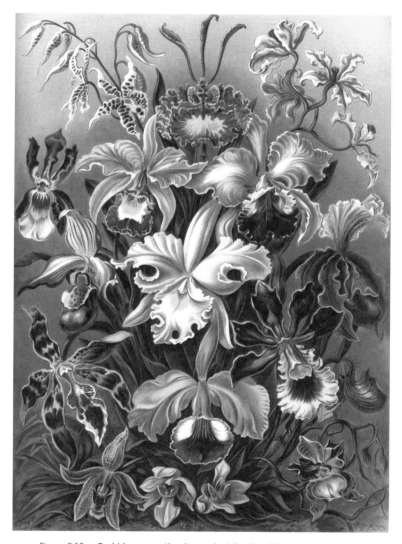

Figure 5.10 — Orchids are another large plant family with some twenty-eight thousand members, most of which live in the tropics. In warm climates, most orchids grow in trees and are epiphytic, meaning that they absorb moisture and nutrients from the air through aerial roots. With blossoms consisting of three sepals and three petals, orchids have evolved creative strategies for attracting pollinators. Some lure insects with sweet or fetid odors. Others resemble female insects, while some resemble males, causing male insects to "attack" and get covered in pollen in the process.

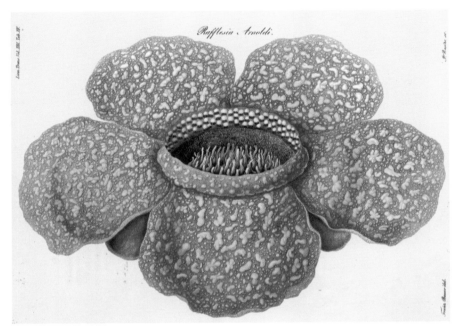

Figure 5.11 — The world's largest flower, which grows in Indonesia, is also
one of the strangest. The foul-smelling *Rafflesia arnoldii*, a parasitic
plant with a fleshy orange blossom, weighs up to fifteen pounds and spans
more than three feet wide.

*facing page*

Figure 5.12 — Wolffia, or duckweed, is the world's smallest flowering plant.
A bouquet of a dozen blooming wolffia fits on the head of a pin.
All thirty-eight members of this family of diminutive aquatic plants lack
true leaves and stems. They grow on the surface of ponds, swamps,
and slow-moving streams.

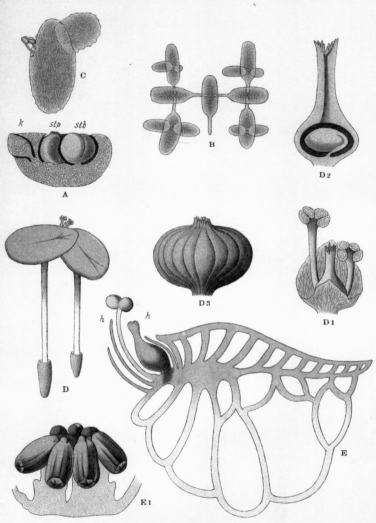

k  stp  stb

104. A. *Wolffia arrhiza Wimmer.*    Wurzellose Wolffie.

B u. C. *Lemna trisulca L.*    Dreifurchige Wafferlinfe.

D. *Lemna minor L.*    Kleine Wafferlinfe.

E. *Lemna gibba L.*    Buckelige Wafferlinfe.

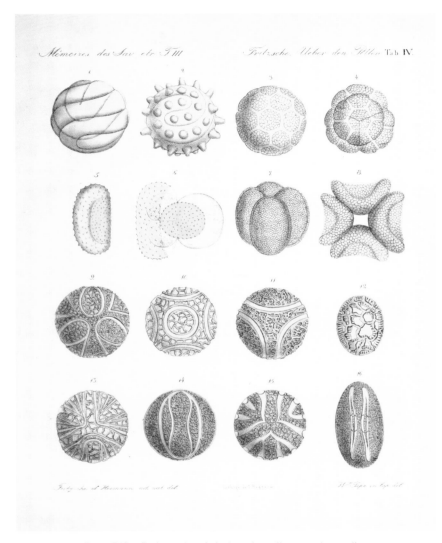

Figure 5.13 — **Each species of plant produces its own unique pollen, microscopic packets that contain a plant's male sex cells. Pollen must protect its precious genetic cargo from drying out as it is transported by wind, insects, or other animals on a sometimes long and perilous journey. To that end, most kinds of pollen grains can fold up like origami to seal in moisture and prevent dehydration in transit.**

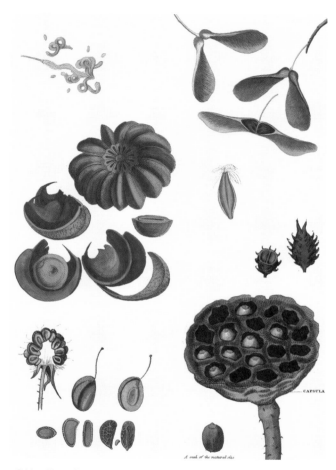

Figure 5.14 — Plants have evolved fascinating design strategies for dispersing seeds via wind, water, or animals. Some wind-riding seeds sport wings, such as maple samaras (top right), while others, such as milkweed, drift on a parachute of down called a pappus (center). Seeds spread by animals either hitchhike on the creatures' bodies or are carried inside their digestive tracts. For example, burdock seeds (middle right) are studded with sticky hooks that readily attach to fur. Other plants, such as raspberries (bottom left), encase their seeds in enticing fruit. Creatures who eat the fruit later deposit seeds in a packet of fertilizer—their poo. The seeds of the sacred lotus (bottom right) disperse by water and can remain viable for 1,300 years. Most dramatically, some plants employ exploding pods to scatter seeds, such as *Hura crepitans*, "the sandbox tree"—a tropical tree with woody pods about the size and shape of tangerines (middle left). When sandbox tree pods burst open, they can fling their nickel-sized seeds more than 150 feet! A more understated seed-flinger is jewelweed (top left), an orange, snapdragon-like wildflower common in the United States.

# *Master Builders*

## Arthropod Engineers

Despite their miniscule brains, insects and spiders have solved some of the most complicated problems in architecture and engineering. Some insects construct portable dwellings that serve multiple purposes, and others build structures of mathematical perfection. Some have mastered the secrets of climate control, and others employ components and make materials that are remarkably strong and lightweight. When it comes to engineering and design, arthropods are masters of ingenuity.

One of the most intriguing examples of insect architecture may be in your nearest pond or stream. Peer into the shallows and you might spot a bean-sized clump of pebbles or twigs trundling along the bottom. Your eyes aren't deceiving you—this is the clever "case" of a caddisfly larva.

Most caddisfly larvae build cases—portable homes that serve as armor and camoflage—to protect themselves from predators ranging from larger insects to trout. Each of the thousands of case-building species makes a distinctive home from specific materials by binding the materials together with strong, stretchy silk. Log cabin caddisflies, for instance, fashion plant fibers into tidy, four-sided cases. Many species that live in fast streams build pebble cases to weigh themselves down against strong currents. Some even adorn their dwellings with the shells of freshwater snails.

While caddisfly larvae construct individual shelters, social insects such as bees, wasps, termites, and ants collaborate on communal structures that have inspired scientists and architects for centuries. Perhaps the most famous example is the honeycomb.

Thinkers from the ancient Greeks and Romans to Charles Darwin have pondered the honeycomb's hexagonal cells, which serve as storage vessels and nurseries. Why do bees use hexagons? In 36 BC Roman scholar Marcus Terentius Varro proposed that dividing a flat plane into equal hexagons is the most efficient way to pack the most surface area into the smallest perimeter. This idea came to be known as the "honeycomb conjecture." Greek mathematician Alexander of Pappus expanded on the theory a few centuries later, and Darwin wrote in the 1850s that the honeycomb is "absolutely perfect in economizing wax and labor." It wasn't until 1999, however, that the conjecture was proven by American mathematician Thomas Hales.

Bees begin making honeycomb with closely packed tubes of wax. They are thought to then use body heat to melt these tubes into hexagons, leaving no gaps between the cells. Their papermaking cousins the wasps also fashion hexagonal cells to shelter their larvae but employ a different material and method. The bald-faced hornet, for example, uses its antennae as measuring sticks to make sure the walls of adjacent cells intersect in a symmetrical "y" shape with legs of equal length. This process creates a honeycombed structure of hexagonal cells.

The hornets' balloon-shaped nests take the prize for elegance in insect architecture, but the towering mounds of termites are the most impressive. Mixing soil with their saliva into a kind of cement, some species build mounds up to thirty feet high. What's truly astonishing, however, is how termite mounds function. Porous on the outside and riddled with ducts and chimneys on the inside, these structures were long thought to warm and cool the termites' underground nests. Recent research, however, shows that termite mounds function as giant lungs—bringing in fresh oxygen and releasing carbon dioxide produced by the up to three million termites living below.

Like termites, ants excavate intricate nests of chambers and galleries. Fire ants, however, also assemble bridges, towers, and

even rafts from unusual components—their own living bodies. When flooded out of their homes in the Amazon, thousands of fire ants grab onto each other with their jaws and claws and link their bodies to make living rafts that are remarkably buoyant, thanks, in part, to their water-resistant exoskeletons. Following a few simple rules—for example, no more than three ants can pile on top of any other ant—they constantly reconfigure their raft as they float down a river, shape-shifting like an amoeba around rocks and other obstacles. When a raft of fire ants reaches land, they may build living bridges to cross small streams, towers to reach food sources, and tents to shelter the colony until they can excavate a new nest.

The most remarkable construction material made by arthropods is spider silk. Ounce for ounce, it has nearly the same tensile strength (resistance to breaking under tension) as steel. Spider silk begins as liquid and solidifies upon contact with air as a spider draws it out from its abdomen with six spinnerets. Spiders make different kinds of silk, including stretchy silk for the center of the web, sticky silk to capture prey, and extra-strong silk that serves as anchor lines.

From these various silks, the orb weaver spins its classic web in a single night. The spider begins with the frame, then lays down up to thirty nonsticky spokes that serve as walkways. It then weaves a sticky spiral between the spokes to capture insects. After laboring on a structure that may include more than one thousand points of connection, some species of orb weavers devour their damaged webs toward dawn—replenishing the proteins they need to make a new batch of silk for the next night.

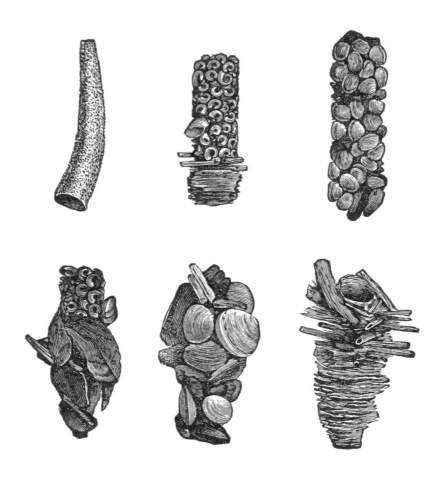

Figure 6.1 — Caddisflies are thought to be named after the "caddice men" of
Elizabethan England, fabric peddlers who pinned samples of their wares to their jackets.

Most of the 14,500-plus species of caddisfly larvae build protective cases using
pebbles, grit, or plant materials bound together with their remarkable silk, which is like
double-sided tape that maintains its stickiness in water. When they are ready
to undergo metamorphosis, these aquatic larvae seal themselves inside their cases
and emerge weeks later as winged adults.

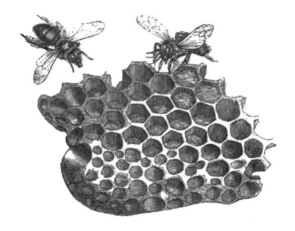

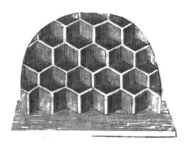

Figure 6.2 — Beeswax is expensive to make—a bee must consume eight ounces of honey to make one ounce of wax—but bees are thrifty builders. The hexagonal shape of honeycomb cells enables bees to pack in the most storage chambers for nectar, honey, pollen, and larvae within the smallest perimeter using the least amount of wax.

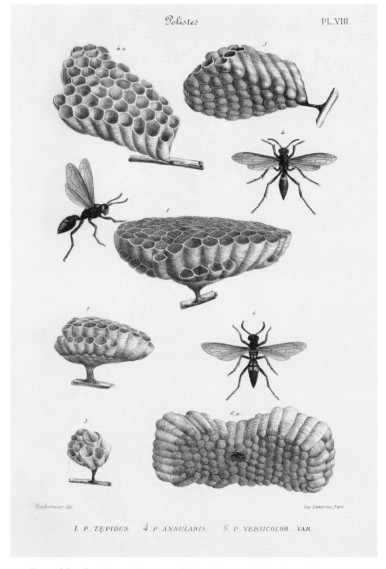

Figure 6.3 — Only three shapes can fit together on a flat surface with no gaps in between: squares, equilateral triangles, and hexagons. Of these, the hexagon is the strongest and most efficient. In addition to honeybees, paper wasps construct hexagonal cells to shelter their larvae.

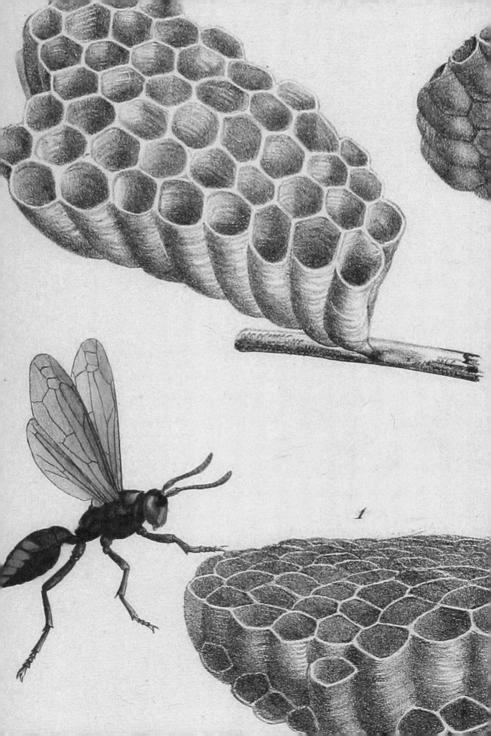

1

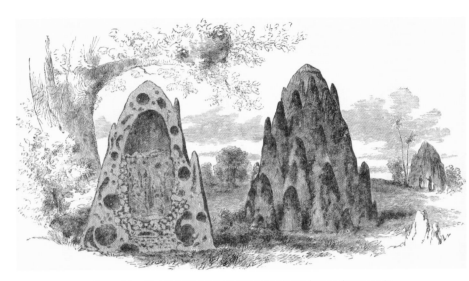

Figure 6.4 — **The termite nests of Africa and Australia may house up to three million insects, which generate a cow's worth of carbon dioxide every day. The insects' towering mounds vent this gas and pull in fresh oxygen.**

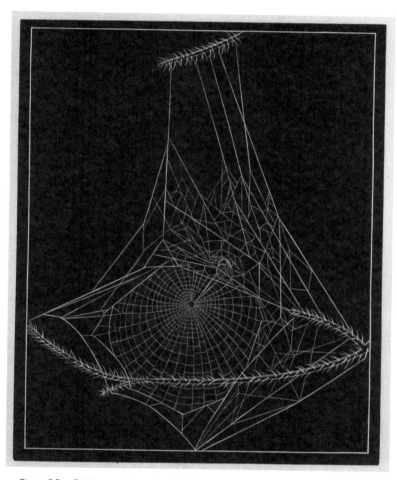

Figure 6.5 — Spiders make four basic kinds of webs: the orb, the funnel, the triangle web, and the tangled web, or cobweb. Of these, the orb is the most well-known and is thought to be the earliest spiderweb design. There are always exceptions to the rule: the web of the labyrinth spider shown in this stylized diagram is a combination of orb and funnel webs. And there are superstars. The unassuming Darwin's bark spider, discovered in Madagascar in 2009, is less than an inch long but makes the biggest web—and the strongest biological material ever studied. Anchor lines can be up to eighty-two inches long, and the web itself can range from 140 to more than 3,400 square feet.

# Arresting Nests

## Avian Architects

The word "nest" may conjure a simple cup of woven grass, but birds build a stunning array of complex structures from diverse materials to shelter their eggs and chicks. Baltimore orioles, for instance, make upwards of ten thousand stitches to weave pendulous nests of plant fibers. Social weaverbirds construct massive colonial nests up to twenty-five feet long and fifteen feet wide. Cave swiftlets of Southeast Asia build nests from their own saliva, which solidifies into translucent strands.

Like human dwellings, birds' nests typically consist of an outer structure, or shell, and insulation. Forms range from the classic cups of many songbirds to pendulums and platforms to domes and mounds, as well as burrows, cavities, and anchored rafts. Materials include all manner of branches and twigs, plant fiber and down, strips of bark, vegetation, bud scales, rootlets, moss, lichen, mud, fur, feathers, spider silk, shreds of paper-wasp nests, and even trash. Great crested flycatchers often weave the shed skins of snakes into their nests.

Although instinct informs nest building, most birds must still find and gather a particular array and surprising quantity of materials. For example, the long-tailed tit, a sparrow-sized bird of the British Isles, collects approximately 1,500 feathers, 3,000 flecks of lichen, up to 300 moss sprigs and 600 or so spider-silk egg cocoons to build its cushiony nest. Just as remarkable, the spider silk and the moss the bird uses for the nest walls stick together like Velcro.

Some species are minimalists. Many seabirds and shorebirds, such as piping plovers, lay their eggs in a shallow scrape in the sand or on bare ground, sometimes decorated with pebbles or bits of

shell. Yet even such simple nests are made with precision. For example, pectoral sandpipers, who nest in the Canadian Arctic, must excavate their scrapes to the right depth. If the scrape is too deep, the eggs might be perilously chilled by permafrost. If it's too shallow, the eggs are exposed to dangerous wind chills.

Other avian architects are maximalists. The most lavish of all are the male bowerbirds of Australia and New Guinea. They don't build nests, but construct elaborately decorated bowers to lure females. The Vogelkop bowerbird, which resembles a drab robin with a down-curved bill and lives in Western New Guinea, constructs the most elaborate seduction chamber of all. First, he builds a "maypole" structure thatched with hundreds of interlocking sticks and orchid stems that may stand more than six feet tall. He then decorates the bower floor and "yard" with piles of flowers, fruit, moss, fungi, deer droppings, leaves, and dead beetles—all meticulously organized by color. When a female approves of a male's efforts, the birds mate and she builds a simple cup-shaped nest for her eggs.

The nests and other structures made by the world's more than ten thousand species of birds are works of both beauty and functionality. The architectural genius of birds has enabled them to inhabit every continent and raise their families in nearly every nook and cranny of the planet—from deserts and rainforests to mountaintops and the barren shores of Antarctica.

It's worth pausing to contemplate the nest. Take a walk to look for nests in autumn after the trees have shed their leaves. If you're lucky enough to find one, try dissecting it and counting how many different materials were used. Imagine trying to make such a marvelous structure yourself—without using your hands.

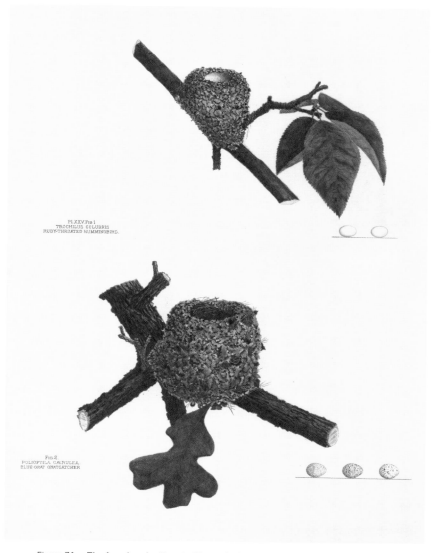

Pl.XXV.Fig 1
TROCHILUS COLUBRIS
RUBY-THROATED HUMMINGBIRD.

Fig.2.
POLIOPTILA CÆRULEA.
BLUE-GRAY GNATCATCHER

Figure 7.1 — The female ruby-throated hummingbird makes a classic cup nest about the size of a walnut. She affixes a patch of sticky spider silk to a tree branch, pads it with plant down, adds bud scales and other materials, and molds it into a cup by turning her body round and round. The final step is shingling the exterior with bits of lichen to camouflage the nest from predators.

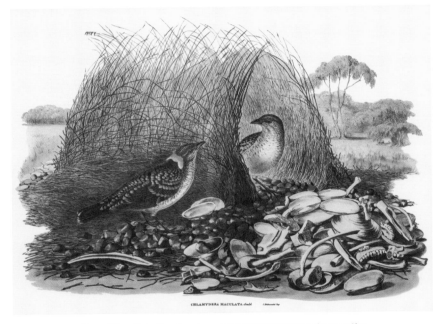

CHLAMYDERA MACULATA.-Gould.    J.Holmandel lith

Figure 7.2 — Male Vogelkop bowerbirds "garden" up to nine months
of the year, festooning their "yards" with a wide variety of items,
such as shells, bones, seeds, fruit, flowers, and other natural materials—
all to attract a mate.

*facing page*

Figure 7.3 — Orioles weave pendant, or pensile, nests from grasses,
hair, and other fibers, making thousands of knots and upward of ten
thousand stitches in the process.

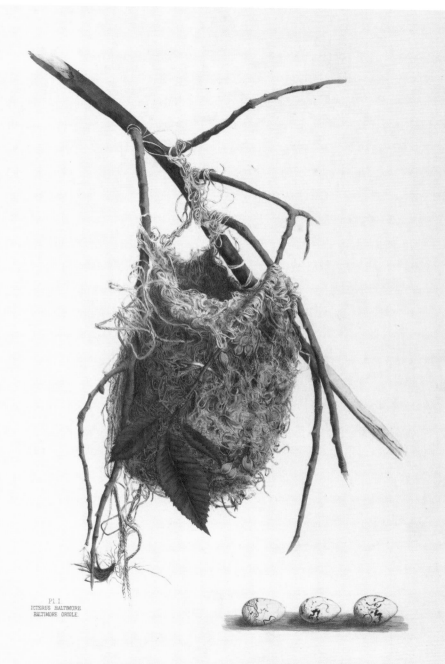

Pl. I
ICTERUS BALTIMORE
BALTIMORE ORIOLE.

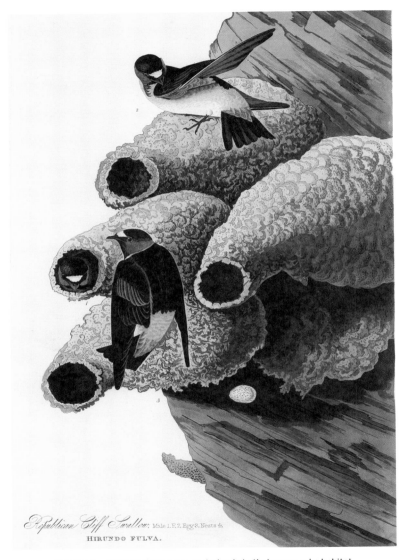

Republican Cliff Swallow; Male 1.F.2. Egg 3. Nests &.
HIRUNDO FULVA.

Figure 7.4 — Cliff swallows once nested only in their namesake habitat,
but they have adapted to humans and now build their nests of mud under bridges,
highway overpasses, and the eaves of buildings. Nesting in colonies, they flock
to puddles and along the shores of streams and ponds to gather mud one tiny beak-
ful at a time, then fly back to cement it in place. A single cliff swallow nest is made
of between nine hundred and twelve hundred pellets of mud.

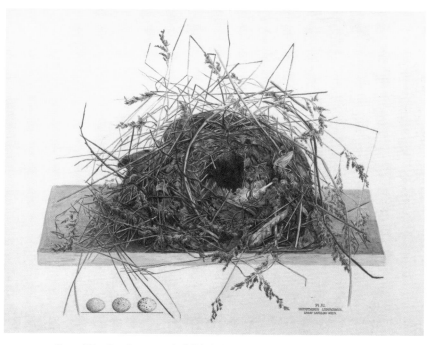

Figure 7.5 — Carolina wrens build their dome-shaped nests in open cavities between three and six feet off the ground. Sometimes using tree stumps, they also will nest in clothespin bags, plant pots, boots, bags, and even the pocket of a jacket left outside. These adaptable birds weave nests from a range of materials, including grasses, dead pine needles, feathers, snake skins, and strips of plastic. Their nests typically have a side entrance, often sheltered with a woven vestibule.

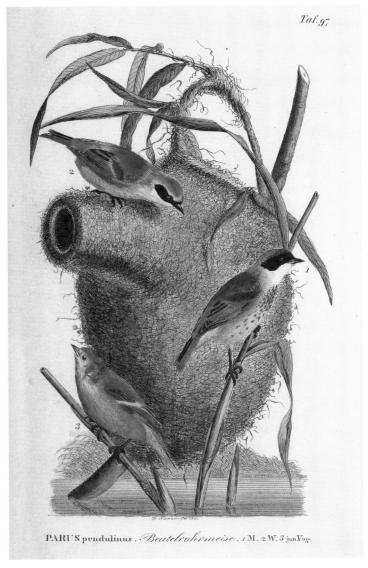

*Taf. 97*

PARUS pendulinus . *Beutelrohrmeise* . 1 M. 2 W. 3 junVog.

Figure 7.6 — The Eurasian penduline tit often constructs its cushy
nest of nettle, grass, and plant down over water along the wooded edges
of marshes. A tubelike entrance on one side near the top serves
as the entrance lobby.

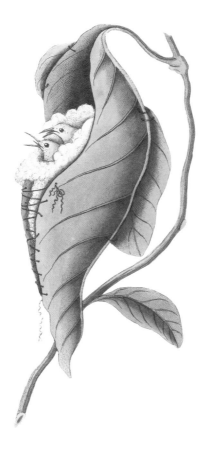

Figure 7.7 — The common tailorbird of tropical Asia fashions its nest from a living leaf stitched together with plant fiber. Small olive-green birds with chestnut caps and long tails, both male and female tailorbirds share in nest building.

The female chooses a leaf still attached to a shrub or tree and checks it for size by wrapping it around her body. If the leaf suits her, she uses her needlelike beak to puncture tiny holes along its margin and stitches the sides together with plant fibers or silk from spiderwebs or cocoons, making between 150 and 200 stitches. Once this leaf cup is complete, the male fills it with fine grasses and lines the sides with plant down and animal hair. The female soon lays up to five eggs, which she incubates for twelve days. Safe inside their cozy nest, the chicks fledge in three weeks.

Figure 7.8 — The nest of a red-headed woodpecker is a classic example of a cavity nest. This species often chooses a dead or dying tree that has lost its bark, creating a smooth surface that may deter snakes. Although females help, males do most of the excavating, chipping out a gourd-shaped cavity in twelve to seventeen days. While a woodpecker hammers away, its long tongue wraps around its skull and serves as a shock absorber.

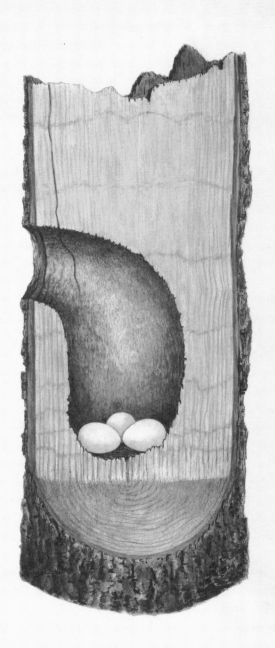

PL. XLIV.
MELANERPES ERYTHROCEPHALUS.
RED-HEADED WOODPECKER.

# Animal Architects

## Beavers and Prairie Dogs

Imagine creating a pond-dotted wetland from scratch without so much as a shovel. How about building an entire "town" that enriches the landscape and hosts a wide diversity of visitors? These feats might seem impossible, but not for nature's most impressive landscape architects: beavers and prairie dogs.

Beavers shape the landscape more than any animal other than humans. The mere sound of running water can trigger them to build dams. As a beaver colony grows, chains of small ponds form, creating verdant wetlands that provide a home to hundreds of species of fish, amphibians, reptiles, birds, insects, and mammals, as well as diverse plant life.

These furry hydrological engineers dam streams to create and maintain ponds at specific depths—not too deep, but deep enough to keep the entrances to their lodges under water, and to prevent ponds from freezing solid in winter. Beavers begin a dam by laying a low foundation of branches on the bottom of a stream and weighing it down with rocks and mud. Over this, they stack sticks, branches, and felled trees up to ten inches in diameter, anchoring the larger, gnawed ends in the streambed. They then caulk the structure with plant debris and mud.

Remarkably, beavers build curved dams to withstand strong currents and straight dams across slow-moving streams. A family or colony may construct a dozen dams over the same stream, maintaining them daily and often over many generations. The largest beaver dam in the world, located in Alberta, Canada, is more than a half-mile long and can be seen from space.

Beaver lodges are also marvels of construction. Made of streamside trees, such as aspen, willow, and cottonwood, a lodge can be as large as a living room. Each lodge houses a family and contains a cozy chamber that serves as a nursery, family room, and bedroom. The winter pantry is right outside the front door: a cache of submerged branches covered with nutritious bark. In cold climates, beavers plaster their lodges with mud, which freezes into a thick cement that protects them from coyotes and other predators.

While beaver dams sometimes flood roads and property, their hydrological engineering can greatly benefit humans. For example, beaver dams mitigate both droughts and floods by storing water and slowing its flow and rate of evaporation. As climate change worsens drought in the western United States, scientists and ranchers in some regions are reintroducing beavers, whose brilliant landscape architecture is restoring wetlands—and life—in places that in some cases have been parched for decades.

Like beavers, prairie dogs alter the landscape as they create their homes. These highly social ground squirrels excavate extensive networks of burrows, which can be a foot wide, more than thirty feet long, and as deep as ten feet underground. Each burrow includes a nursery, a latrine, bedrooms, and a listening chamber near the entrance. An extended family, or "coterie," of prairie dogs digs and maintains each burrow, in the process mixing and aerating the soil like fat, furry earthworms.

Prairie dogs live in colonies called "towns," and a single acre of prairie may harbor between four and one hundred burrows. These herbivores spend much of their spring and summer days like suburbanites—mowing the grass and pruning flowering plants, letting nothing grow more than a foot tall. They keep the vegetation low to be better able to spot predators, such as badgers, coyotes, and the endangered black-footed ferrets.

Like good townsfolk, prairie dogs look out for one another. When they're not grazing or pruning, they keep watch atop mounds

of soil up to three feet high at their burrow entrances, and warn their neighbors of danger. Scientists have found that prairie dogs' language of barks and yips is so sophisticated that they can describe different predators in detail—from ferrets to humans with guns.

Long believed to compete with cattle for grazing lands, prairie dogs have been eradicated from 95 percent of their historic range by shooting, poisoning, and habitat destruction, as well as bubonic plague, to which they're extremely susceptible. Scientists have discovered, however, that prairie dog activity can improve the quality of plant life. For example, plants pruned by prairie dogs take up more nitrogen from the soil, making them more nutritious.

These four-footed landscape architects are keystone species— beings upon whom entire ecosystems depend. The earthworks and "gardening" of prairie dogs have created a habitat that supports more than two hundred animal species, from bison who often prefer to graze in their towns to burrowing owls, who shelter and nest in abandoned prairie dog tunnels.

Beavers and prairie dogs contend with many of the same challenges facing human landscape architects, such as managing water and creating sustainable communities. Their dams, dwellings, and communities demonstrate that it's possible to not only make a landscape more beautiful, but also enrich it, creating a habitat and home for many other creatures.

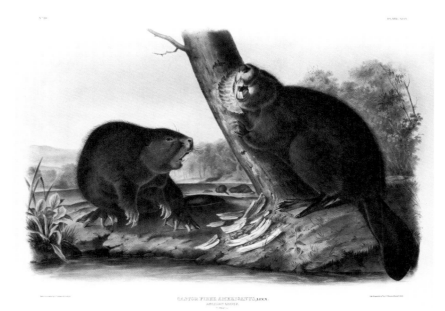

Figure 8.1 — One adult beaver can gnaw down more than two hundred trees in a year. They are perfectly equipped for the job with self-sharpening incisors that grow constantly. Beavers' teeth are fortified with iron, which gives them an orange tint.

*facing page*

Figure 8.2 — A beaver family or colony may construct a dozen dams across the same stream and maintain them for generations. Lodges are made of twigs and branches and are not as smooth and symmetrical as this whimsical depiction suggests. Beaver dams are surprisingly strong and can be massive. As Lewis Henry Morgan observed in his 1868 book, *The American Beaver and His Works*, one beaver dam was so sturdy and wide "that a horse and wagon might have driven across the river upon it in safety."

Parts of what is now the American West were once much more fertile due to beavers. Beginning in the late 1500s, the fur trade eventually brought beavers to the brink of extinction in many places, and the intricate networks of ponds and wetlands that they created have disappeared.

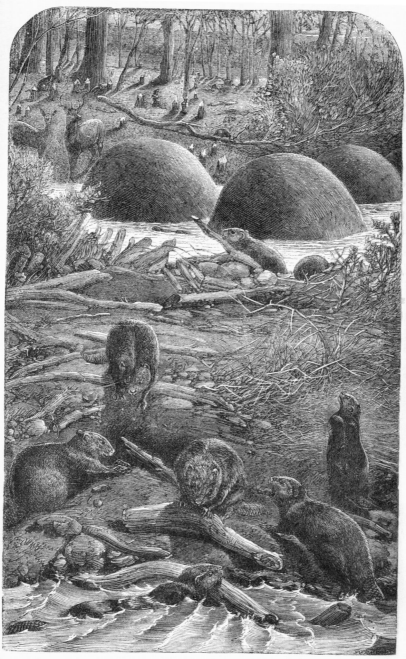

THE BEAVER AND ITS HOME.

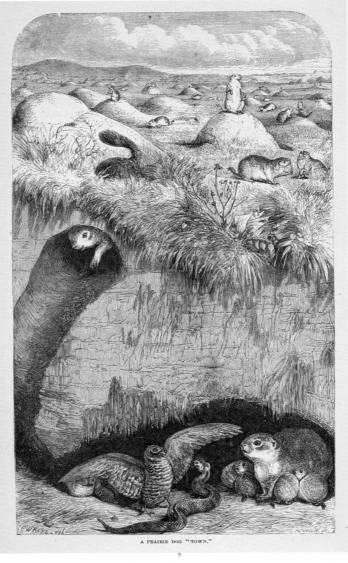

A PRAIRIE DOG "TOWN."

Figure 8.3 — **The burrowing activity of prairie dogs turns over nearly six tons of desert soil per acre. Bison, antelope, and elk prefer to graze in prairie dog towns, where the plants and grasses have been found to be higher in nitrogen and protein thanks to constant pruning by these furry landscapers. More than one hundred species shelter in their burrows, including burrowing owls, rattlesnakes, and endangered black-footed ferrets.**

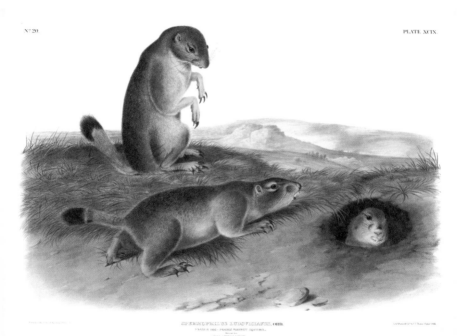

Figure 8.4 — Like beavers, prairie dogs are extraordinary landscape architects. Their "towns" were once astonishingly vast. Lewis and Clark encountered prairie dogs in 1804 in what is now Nebraska. Clark described a hillside pocked with "a great number of holes on top of which these little animals Set erect make a Whistling noise and whin alarmed Step into their hole." They managed to capture one and send it to Thomas Jefferson, and surprisingly, the little creature survived the trip. Lewis referred to them as "barking squirrels," and Clark called them "ground rats" or "burrowing squirrels." An army sergeant named John Ordway is credited with first calling them prairie dogs.

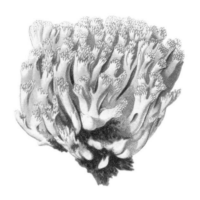

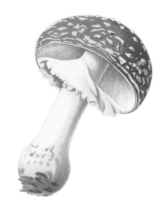

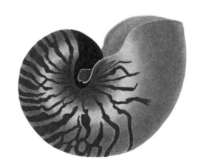

# A Living Library

*Nothing is invented, for it is written in nature first.*
—ANTONI GAUDÍ

Catalan architect Antoni Gaudí designed his celebrated Sagrada Familia basilica and many other buildings based on trees, flowers, and other natural forms. He wasn't alone. Humans have always looked to nature for inspiration in creating beautiful, functional, and durable buildings and other necessities of life.

That quest continues today in the emerging field of biomimicry in which architects, engineers, scientists, and designers study and emulate nature to overcome human design challenges. They are learning from hundreds of organisms—including some of the wondrous wild designers in this book. For instance, architects in South Africa designed a 55,000-square-foot building that mimics the climate control and ventilation systems native termites use in their sophisticated mounds. Materials scientists, who study the properties and structures of natural and human-made materials, are investigating how diatoms make their intricate silica shells in order to develop new nanotechnologies that more precisely deliver drugs to kill cancer cells in the body. Engineers are designing more durable glass inspired by the microscopic structure of mother-of-pearl in seashells. The list goes on.

In short, nature is a living library, a repository of knowledge that has evolved over hundreds of millions of years. Nature's wild designers offer encyclopedias and how-to manuals on making extraordinary structures and materials—without polluting or

impoverishing the neighborhood. Yet we have barely begun to discover their secrets of truly sustainable design.

Meanwhile, the clock is ticking. One million species of plants and animals are at risk of extinction, according to the United Nations Intergovernmental Science-Policy Platform on Biodiversity and Ecosystem Services. The culprits? The negative consequences of human activity, including climate change, pollution, and rampant development. Scientists recently noted that for the first time in history, we humans are now the main drivers of dramatic changes to our planet's atmosphere and ecosystems.

But each of us still has a choice. It begins with deciding to pause. Any time we stop, even briefly, to observe a tree outside the window, or a spider's intricate web, snowflakes caught on our jacket sleeve, or any bit of nature, a slight shift happens. We reconnect with the world around us.

If we share the everyday marvels we notice with one another, the effect multiplies. Imagine this happening many millions of times a day. Who knows what might transpire?

Change, for better or worse, is cumulative. The more of us who get to know and appreciate the brilliance of our other-than-human neighbors, the greater the chances that our collective sense of wonder will deepen. May we grow in wonder for our home planet, and may this inspire us to act, in our own small ways, on its behalf.

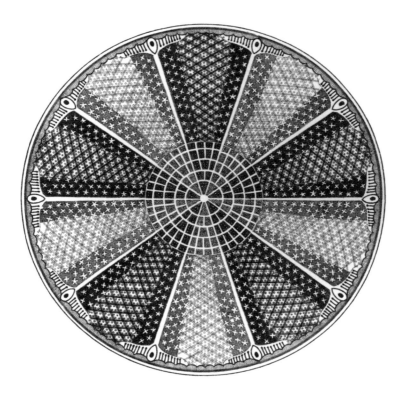

# Acknowledgments

This book grew from a notion to the volume you hold in your hands thanks to an ecosystem of great minds and hearts. I offer my deepest thanks to the following people for helping to bring *Wild Design* into the world: Jan Hartman, who planted the seed and nurtured this project through the tender time of germination; editors Jennifer Thompson and Stephanie Holstein, who provided the expertise and enthusiasm that are as essential as sunlight, soil, and water; and architect and researcher Misha Semenov, who delved into the vast Biodiversity Heritage Library like an intrepid explorer to find exquisite illustrations, bringing his keen aesthetics and spectacular organizational skills to the task.

I also would like to thank those who generously shared their brilliance and knowledge along the way. My writers group helped me hone early drafts with their excellent critiques. Thank you Ellen Booraem, Kathleen Caldwell, Heidi Daub, Irene Eilers, Jean Fogelberg, Ann Logan, Becky McCall, and Gail Page. Dr. Alicia Cruz-Uribe, School of Earth and Climate Sciences, University of Maine, reviewed the minerals chapter for accuracy, sharing her expertise and passion for geology. Ecologist Cathy Rees reviewed the botany chapter and gave me a deeper and broader appreciation of thigmomorphogenesis. Dr. David Porter, Professor Emeritus, Department of Plant Biology, University of Georgia, made invaluable comments on the fungi chapter and first introduced me to the wonders of mycorrhiza on an island in Maine years ago.

I bow in gratitude to Tom Curry for his constant love and belief, and to the web of wild wonders all around us.

# Bibliography

ARNDT, INGO and TAUTZ, JÜRGEN. *Animal Architecture.*
New York: Abrams, 2013.

BALL, PHILIP. *Patterns in Nature: Why the Natural World Looks the Way
It Does.* Chicago: The University of Chicago Press, 2017.

GOODFELLOW, PETER. *Avian Architecture: How Birds Design, Engineer
and Build.* Princeton: Princeton University Press, 2011.

HAZEN, ROBERT M. *The Story of Earth: The First 4.5 Billion Years, from
Stardust to Living Planet.* New York: Viking Penguin, 2012.

HENNESSEY, KATHRYN, Ed. *Natural History: The Ultimate Guide to
Everything on Earth* (Smithsonian). New York: DK, 2010.

# Illustration Credits

Pages 2, 20, 61, 66: Oscar Réveil, *Le Règne vegetal*, 1870. Paris: L. Guérin.

Page 8: Marc Athanase Parfait, *Musée ornithologique illustré : description des oiseaux d'Europe*, 1886. Paris: J. Rothschild.

Page 13: Great Britain's Royal Microscopical Society, *Quarterly Journal of Microscopical Science*, 1853. Oxford: Clarendon Press.

Pages 14, 16, 19: Max Bauer and Leonard James Spencer, *Precious Stones*, 1904. London: C. Griffin & Co.

Pages 17, 18: James Sowerby, *British Minerology*, 1802. London: R. Taylor & Co.

Page 21: Oliver B. Bunce and William C. Cullen, *Picturesque America*, 1872. New York: D. Appleton.

Pages 25–27, 58, 59 (detail), 69, 107 (detail): Ernst Haeckel, *Kunstformen der Natur*, 1904. Gotha: Bibliographisches Institut.

Pages 28, 29: Julius Wiesner, *Frustules of Diatoms*, ca. 1870. Cyanotype. The Metropolitan Museum of Art, New York.

Pages 33–35, 38, 112 (detail): Lovell Reeve, *Conchologia Iconica*, 1843. London: Reeve Brothers.

Pages 36, 104 (bottom detail): John Chapman and John Wilkes, *Encyclopaedia Londinensis*, 1810. London: J. Adlard.

Page 37: Charles Dessalines d'Orbigny, *Dictionnaire universel d'histoire naturelle résumant*, 1861. Paris: L. Houssiaux et Cie.

Page 40: Henri de Lacaze-Duthiers, *Histoire naturelle du corail*, 1864. Paris: J.B. Ballière.

Page 41: William Saville-Kent, *The Great Barrier Reef of Australia*, 1893. London: W.H. Allen.

Pages 45, 47–50, 104 (top and middle detail): Léon Dufour, *Atlas des champignons comestibles et vénéneux*, 1891. Paris: P. Klincksieck.

Page 46: Émile Boudier, *Icones mycologicæ*, 1905. Paris: P. Klincksieck.

Pages 51, 52: Berthold Seemann, *Journal of Botany*, 1863. London: R. Hardwicke.

Page 53: Pierre Bulliard, *Herbier de la France*, 1780. Paris: Chez l'auteur, Didot, Debure, Belin.

Page 60: Anne Pratt, *The Ferns of Great Britain*, 1855. London: Society for Promoting Christian Knowledge.

Page 62: William Curtis, *Curtis's Botanical magazine*, 1790. London: T. Curtis.

Page 63: François Pierre Chaumeton, *Flore médicale*, 1833. Paris: Imprimerie de C.L.F. Panckoucke (top left and right); François André Michaux, *Histoire des arbres forestiers de l'Amérique septentrionale*, 1812. Paris: L. Haussmann (bottom left); François André Michaux, *The North American Sylva*, 1865. Philadelphia: Rice, Rutter & Co. (bottom right).

Page 64: Thomas Moore, *The Floral magazine*, 1861. London: L. Reeve & Co.

Page 65: Nathaniel Britton, *The Cactaceae*, 1919. Washington: Carnegie Institution of Washington.

**Page 68:** John Miller, *Illustratio systematis sexualis Linnaeani*, 1789. London: Varrentrapp et Wenner.

**Page 70:** Robert Brown, *An Account of a New Genus of Plants: Rafflesia*, 1821. London: Richard and Arthur Taylor.

**Page 71:** Otto Wilhelm Thomâe, *Prof. Dr. Thomé's Flora von Deutschland*, 1886. Berlin: F. E. Khler.

**Page 72:** Carl Julius Fritzsche, *Ueber den Pollen*, 1837. St. Petersburg: Academie der Wissenschaften.

**Page 73:** August Mentz, *Billeder af nordens flora*, 1917. Copenhagen: Gads Forlag (top left); Johan Carl Krauss, *Afbeeldingen der fraaiste, meest uitheemsche boomen en heesters*, 1802. Amsterdam: J. Allart (top right); William Baxter, *British Phaenogamous Botany*, 1834. Oxford: W. Baxter (middle right); Richard Duppa, *Elements of the Science of Botany*, as established by Linnaeus, 1812. London: T. Bensley (bottom right); F. E. Köhler, *Köhler's Medizinal-Pflanzen*, 1883. Berlin: Eugen Köhler (bottom left); Georg Dionysius Ehret, *Plantae et papiliones rariores*, 1748. London (middle left); Joseph Franz Jacquin, *Eclogae plantarum rariorum aut minus cognitarum*, 1811. Vienna: Sumptibus auctoris (center).

**Page 78:** Dwight Sanderson, *Elementary Entomology*, 1912. Boston: Ginn.

**Page 79:** Charles Knight, *The Pictorial Museum of Animated Nature*, ca. 1844. London: C. Cox.

**Pages 80, 81:** Henri de Saussure, *Études sur la famille des vespides*, 1852. Paris: V. Masson.

**Page 82:** Georg Hartwig, *The Polar and Tropical Worlds*, 1874. Guelph: J. W. Lyon.

**Page 83:** Henry C. McCook, *American Spiders and Their Spinning Work*, 1889. Philadelphia: Academy of Natural Science of Philadelphia.

**Pages 87, 89, 91, 95:** Howard Jones, *Illustrations of the Nests and Eggs of Birds of Ohio*, 1886. Circleville.

**Page 88:** Elizabeth Gould, *Spotted Bower Bird*, 1972. Illustration for John Gould's *Birds of Australia*. Melbourne: Lansdowne Press.

**Page 90:** William Home Lizars, *Cliff Swallow*, 1827. Etching for John James Audubon's *Birds of America*. Edinburgh and London: Adam & Charles Black.

**Page 92:** Johann Andreas Naumann, *Naturgeschichte der Vögel Deutschlands*, 1820. Leipzig: G. Fleischer.

**Page 93:** George Shaw, *The Naturalist's Miscellany*, 1789. London: Noddler & Co.

**Page 100:** John Woodhouse Audubon, *American Beaver (Castor fiber Americanus), 1845. Illustration for Viviparous Quadrupeds of North America.* New York: J. J. Audubon.

**Pages 101, 102:** John George Wood, *Homes Without Hands*, 1866. New York: Harpers & Brothers.

**Page 103:** John Woodhouse Audubon, *American Beaver (Castor fiber Americanus), 1845.* Illustration for *Viviparous Quadrupeds of North America.* New York: J. J. Audubon.

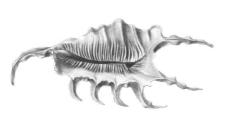